BLACK BOSTON

DOCUMENTARY PHOTOGRAPHY AND THE AFRICAN AMERICAN EXPERIENCE

Exhibition and catalogue by Kim Sichel

with an essay by Edmund Barry Gaither

BOSTON UNIVERSITY ART GALLERY

MARCH 5–APRIL 10, 1994

Photographic Credits: All photographs are courtesy of the artist
unless otherwise noted: Photo Services, Boston University (cover,
figs. 1, 3, 10, 13), Society for the Preservation of New England
Antiquities (figs. 9, 11), Milton Historical Society (figs. 2, 12),
Archives and Special Collections, Northeastern University
Libraries (figs. 4, 14), Boston Public Library (figs. 6, 16).

Boston University Art Gallery
855 Commonwealth Avenue
Boston, Massachusetts 02215

Printed in the United States of America.
Library of Congress Catalogue Card Number:
94-070187

ISBN 1-881450-03-1

CONTENTS

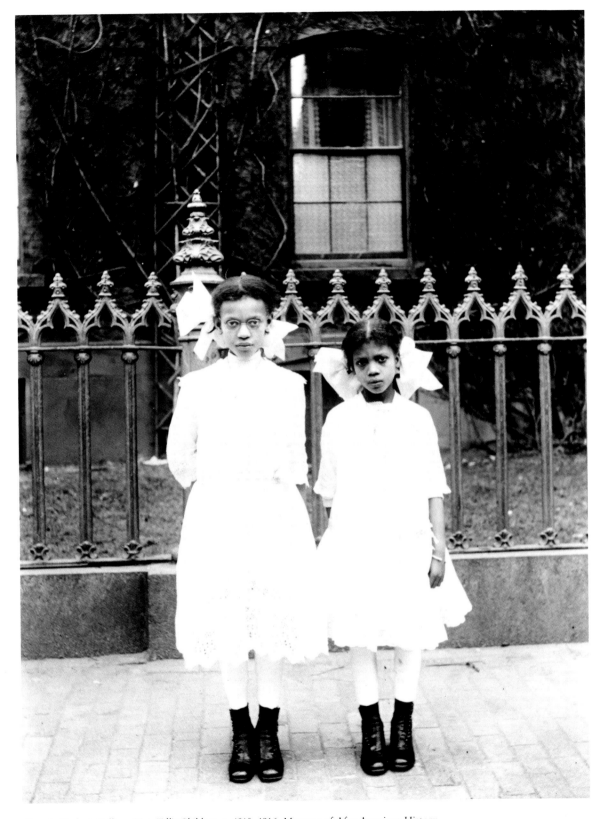

FIG. 1. Herbert Collins, *Mrs. Tell's Children*, c. 1910–1916, Museum of Afro-American History

DOCUMENTARY PHOTOGRAPHY AND THE AFRICAN AMERICAN EXPERIENCE

KIM SICHEL

> *American photographs are not simple depictions but constructions, . . . the history they show is inseparable from the history they enact: a history of photographers employing their medium to make sense of their society.*[1]
>
> —Alan Trachtenberg

In 1945, Aaron Siskind consciously described his documentary approach to photography in the "Harlem Document" project he and other Feature Group members produced within the Photo League.[2] His approach differed somewhat from that of the League, whose philosophy was: "Photography is of tremendous social value. Upon the photographer rests the responsibility and duty of recording a true image of the world as it is today."[3] Yet Siskind's own work often seems carefully composed, and he himself called the Harlem photographs "very quiet and very formal."[4] His approach suggests a greater self-awareness of the role of artistic manipulation than much of the other documentary work of the 1930s, which routinely sought to privilege truth over style. In an article entitled "The Drama of Objects," Siskind wrote:

> *Producing a photographic document involves preparation in excess. There is first the examination of the idea of the project. Then the visits to the scene, the casual conversations, and more formal interviews— talking, and listening, and looking, looking. . . . Finally, the pictures themselves, each one planned, talked, taken and examined in terms of the whole. I worked pretty much this way in making "Harlem Document."*[5]

Aaron Siskind's awareness of photography's social and cultural context, and his attention to the whole scene as well as the single image, provide the premise for *Black Boston*. This exhibition was first planned as a companion to the Boston venue for Siskind's "Harlem Photographs" exhibition concurrently on display at the Boston University Art Gallery.[6] This seemed to be an ideal opportunity to search out some of Boston's little-known documentary photographs of the African American experience. The project soon took on a life of its own, and has challenged our notions about 1) the role of a historical or photographic archive in any form, 2) the role of documentary photography as it developed throughout the twentieth century, and 3) preconceived ideas of who has or has not photographed the black community in this city. Our research took us first to Roxbury, but soon encompassed the whole of Boston's diverse archives and history. We concentrated on the concept of the African American neighborhood in its many shapes and definitions, throughout the century. Yet our attempts to resurrect portions of this archive clearly revealed that any linear kind of "overview" is impossible.

Instead, this exhibition attempts the following tasks. First, it presents samplings of certain important neighborhoods where African Americans have lived or continue to live from 1900 to the present. (The material documenting the period before 1900 is extremely fragmentary.) These examples in no way attempt to define the totality of black communities or regions in the city, or artificially to create a linear history of African American experience. Rather, individual situations are allowed to speak for themselves.

Second, through one case study—the city of Boston—the photographs shed light on the development of documentary photography as a genre during the past hundred years. These pictures parallel major photographic developments from Eugène Atget's and Jacob Riis's early urban imagery at the turn of the century through what is commonly seen as the heyday of documentary photography in the 1930s (the decade of New York's Photo League, the government's Farm Security Administration project, Berenice Abbott's "Changing New York," and the birth of the photographic picture magazine).[7] Finally, the contemporary photographers reflect changing attitudes toward the documentary style, and a self-conscious modesty in the era of postmodern doubts about "truth" and the persuasive power of pictures.

1

Third, the exhibition presents selected groups of extraordinary images, acknowledging that a picture's formal power is an active partner to the message being transmitted. However, several series of images replace single examples, thus avoiding the distortions of one-shot views. These are photographic texts, not single punctuation points. Moreover, the complexity of the neighborhoods seems better served by photographers, whether black or white, who interacted over time with their subjects and sites, so that these groups of images can hint at the multiple levels of meaning that single photographs so easily mask. As a further illustration of the randomness of history, the photographers themselves reflect an interesting demographic split: three are African American men (Herbert Collins, Lou Jones, and Hakim Raquib), four are white women (Polly Brown, Beverly Conley, Irene Shwachman, and Margaret Sutermeister), and two are white men (Jules Aarons and Paul Rowell).

Certain tentative conclusions emerge from this trolling expedition through the archives and among contemporary photographers. In historical and contemporary photographs alike, home and domesticity seem to be key subjects, as is a shared fascination with the diverse definitions of the "homeplace," whether indoors or on the street.[8] Such diverse images as Collins's studio interiors, Rowell's construction sites, Shwachman's Freedom House social gatherings, and Jones's graffiti-covered walls all represent the locus of cultural activity. Whether by black or white photographers, the pictures must be studied in context to understand how they assist in creating Boston's African American community.

Photography as History

The timeline condensed from Robert Hayden's history of African American experience in Boston offers one kind of framework for understanding the development of black communities in this city.[9] It is presented in this catalogue as one of the few ways we have to process historical information. We can say that African Americans lived in the North End, then moved to the north slope of Beacon Hill, then spread out to other portions of the West End, the South End, Roxbury, and eventually to Mattapan, Dorchester, and

other areas throughout Boston. But this process was not linear, and cannot be neatly encapsulated into a demographic timeline. Black Boston's demographic history, in fact, is inextricably intertwined with its other social institutions, its churches, its newspapers, its neighborhoods, and its oral histories.[10] There are gaps and overlaps in these urban histories, and the most effective way to understand them is as a series of fragments.

The same is true for the history of the photographs of these communities. They, too, present a partial tale. In fact, neither supposedly factual history nor supposedly transparent photography transmits the whole truth; all we can hope is to acknowledge and understand the necessarily fragmentary nature of each. Cultural historian James Clifford offers a useful assessment of the changing quality of history, attempting to analyze the invalidity of demonstrating a fixed truth. In recognizing that facts have become fluid, he suggests that:

> *A conceptual shift, "tectonic" in its implications, has taken place. We ground things, now, on a moving earth. There is no longer any place of overview (mountaintop) from which to map human ways of life, no Archimedean point from which to represent the world. Mountains are in constant motion. So are islands, for one cannot occupy, unambiguously, a bounded cultural world from which to journey out and analyze other cultures.[11]*

These thoughts seem particularly relevant to the search for a photographic history of African Americans in Boston. With thousands of photographs lost, buried in basements, or obscured by anonymity, a complete reconstruction of the photographic archive of African American Boston is impossible.

Because of their complexity and multiple purposes, photographic archives and documentary photography present a particular challenge to the historian. Photographic historian Maren Stange provides a useful definition for documentary photography in her book *Symbols of Ideal Life*: "Not the photograph alone then, but the image set in relation to a written caption, an asso-

ciated text, and a presenting agency (such as the reform organization, or, later, the museum) constituted the documentary mode."[12] Documentary photographs cannot exist as pure images; too many other factors help to define their context. Even the "presenting agency" can wear many different guises: government agency, commercial studio, artist's practice, and of course, museum exhibition. In his discussion of the massive 1930s Farm Security Administration/Office of War Information archive, which sets our terms for defining most documentary photographs, another critic, Alan Trachtenberg, carries this argument further. He suggests that the agency itself (here, the United States government) is a cultural construction, as is its filing system for photographic documents. "The file deserves to be recognized as one of the prime cultural artifacts of the New Deal."[13] Trachtenberg reminds us that the viewer, too, plays a role in this cultural history.

> *The danger is to see any photograph as fixed and final, either in order, meaning, or time and place. . . . The file becomes our history only by our acting upon it, deciphering its portent in light of our own view of the times and its anguishes.*[14]

All of these issues contribute to the shape of any history of Boston's African American photography archive. Although individuals emerge as the primary voices of the photographic archive, the nine photographers in this exhibition must be placed into a complex cultural web that includes their lives, their pictures, their subjects, and their patrons or public. Therefore, we need to look at each of these photographic workers in context; their images, however powerful, cannot be read in a vacuum.

In addition to documentary definitions, there is the question of race. Recently much historical prose has been devoted to the issues of race and representation. As the late art historian Guy C. McElroy observed:

> *The ways that America's leading visual artists have portrayed the African-American—as slave or freedman, servant or member of the middle class, minstrel performer or wartime hero, ridiculous stereo-*

type or forceful leader—form an index that reveals how the majority of American society felt about its black neighbors. Naming is a form of power, and visual images have the persuasive power to identify and define place and personality. Whether through portraiture, genre scenes, allegorical history painting, or narrative realism, the work of artists of differing races and ethnic groups has detailed the prevailing negative as well as the rarer positive opinions that one race held for another.[15]

Black historians such as McElroy have discussed the prevailing representations of African Americans. Can white photographers present the black community in those "rarer positive opinions," and can photographers escape stereotypes? Conversely, do black photographers create their own authentic formal language, moving beyond white pictorial models? We believe that both are possible, and the nine photographers in this exhibition present a multiplicity of empathetic voices that may shed light on these issues.

The history of photography and African American subjects includes photographers of both races. The works of Frances Benjamin Johnston, Carl van Vechten, Aaron Siskind, Bruce Davidson, Helen Levitt, John Vachon, and others have entered histories of photography. Until recently only a few African Americans, such as Gordon Parks, Roy de Carava, and James Van Der Zee, have appeared in the standard textbooks, although 247 African Americans were listed as professional photographers in the 1900 national census.[16] Efforts by historians such as Deborah Willis-Braithwaite and Valencia Hollins Coar have done much to fill this void, uncovering such black photographers as daguerrotypist Jules Lion, a free man of color working in the 1840s in New Orleans; Cincinnati photographer James P. Ball, who owned the largest gallery in the West in 1851; and Addison N. Scurlock, a prominent Washington, D.C., photographer of the early 1900s.[17] P.H. Polk and other photographers connected with the Tuskegee Institute are also gaining recognition.

In Boston, the work of early African American

photographers is also being recovered, largely through the efforts of Deborah Willis-Braithwaite.[18] We now know the work of daguerrotypist John B. Bailey (active in Boston during the 1840s), who taught James P. Ball the art of photography. The painter Edward Mitchell Bannister (1821–1901) was photographing in Boston in about 1840. Herbert Collins photographed here from the turn of the century to about 1920. Hamilton Sutton Smith (1857–1924) also worked briefly in Boston and Washington, D.C.[19] A clerk for the U.S. Pension Bureau, Smith lived in Washington, and between 1890 and 1920, photographed some Boston sites such as Revere Beach and Plymouth Rock, as well as various Washington, D.C. parks. R. A. Gilbert (1878–1947) was an assistant to William Brewster, the first president of the Massachusetts Audubon Society, and he photographed with and for Brewster.[20] Yet with the exception of Herbert Collins, and an occasional image by Hamilton Smith, none of these men concentrated on the city of Boston as their subject.

There exist a few individual historical images of the black experience in Boston, including a much-reproduced shot of the historic African Meeting House; a nineteenth-century view of Anderson Street on Beacon Hill owned by the Boston Athenaeum; a series of images owned by the Massachusetts Historical Society of black and white members of the 54th Regiment reviewing the Shaw Memorial during its dedication in 1897. But the archives yield remarkably little, especially in multiple views which might offer a more complex portrait of city life.

Contemporary African American photographers are of course much better known, also largely due to Deborah Willis-Braithwaite, whose biographical dictionaries and exhibitions have highlighted much work.[21] Boston-based black photographers whose work does not concentrate heavily on neighborhoods include Don West, Burton Aukram, Morocco Flowers, Reginald Jackson, Odetta Rogers, and Archy La Salle. Rudolph Robinson, who died in 1987, created powerful photographs of the city, but none are available in print form.[22]

Certain photographic projects have concentrated primarily on Boston, although none have included the African American community as a sole subject. *City Limits: Images of Boston in Transition*, a book edited by Kelly Wise, pays homage to the strength of Boston's diverse communities, from Beacon Hill to Brighton to Mattapan. "Although Boston is no longer a city of homogeneous neighborhoods, the people we met and photographed still demonstrate a strong loyalty to various areas in which they live."[23] This publication addresses the geographical identities of the city's neighborhoods, but it isolates the images from the histories of both subjects and photographers, and by definition includes African American communities among others within the larger city. Another project which addresses neighborhood issues is the UrbanArts presentation "Along the El, An Exhibition of Historical Photographs of the Elevated Orange Line and Washington Street Corridor from 1897–1987."[24]

Perhaps the best model for an exhibition like this one is "Home: Contemporary Urban Images by Black Photographers," presented in the autumn of 1990 at the Studio Museum in Harlem. The museum's chief curator, Dr. Sharon Patton, grouped eleven photographers who document African American life in major American cities. Looking at communities and individuals, she assembled what critic Brian Palmer terms "portfolios that loosely cohere around a simpler concept of home: wherever black city folk are—inside our apartments, on our stoops, and in the street. . . ."[25]

Nine Photographers

"Black Boston" highlights nine photographers whose sustained work in various neighborhoods both reflects and contributes to the identity of the communities they studied. These photographers span almost a hundred years of photographic practice. Three figures, Herbert Collins, Paul Rowell, and Margaret Sutermeister, worked in the early 1900s. Two photographers, Jules Aarons and Irene Shwachman, recorded the city at mid-century. Four others, Polly Brown, Beverly Conley, Lou Jones, and Hakim Raquib, are working currently. Their careers are vastly different; they approach their subjects as workers and as artists, professionals and as amateurs, as community members and as visitors, at one end of the century and at the other. Yet all are committed to the documentary mode,

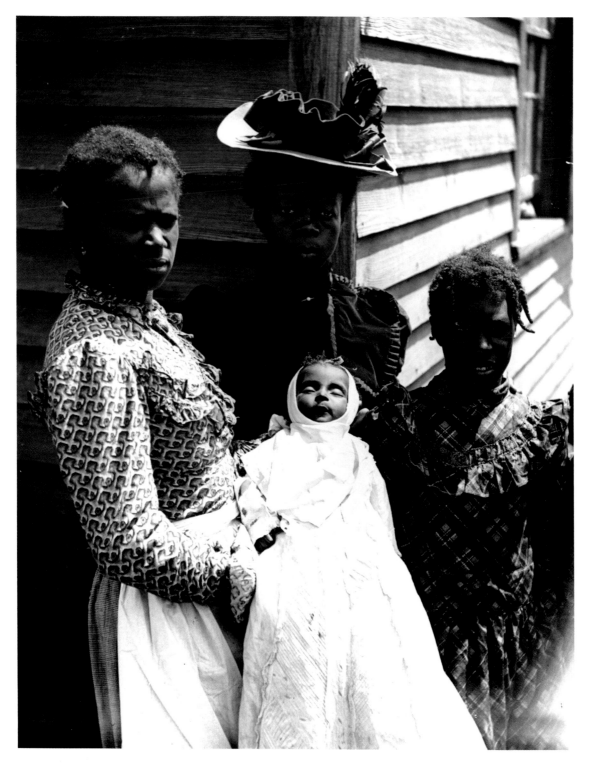

FIG. 2. Margaret Sutermeister, *Postmortem Photograph of an Infant Held by Two Women and a Girl*, c. 1900, Milton Historical Society

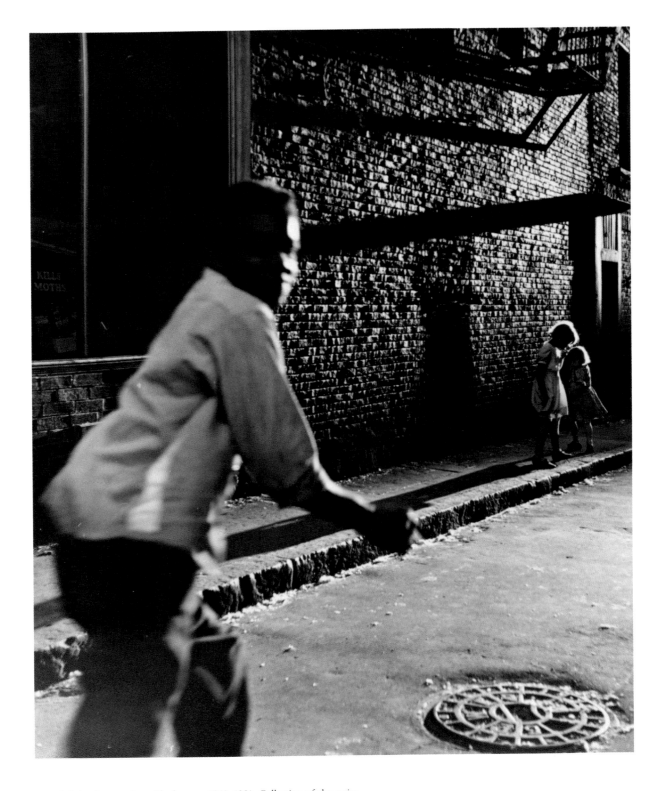

FIG. 3. Jules Aarons, *Long Shadows*, c. 1948–1951, Collection of the artist

as it is defined in their eras. Furthermore, common ground emerges: an overriding consciousness of home-place and community identity informs the work of these photographers. Although they define home for each neighborhood and era in very different ways and for very different uses, each affirms the survival of individuality in the African American community.

Herbert Collins has been recognized as among the important early African American photographers in Boston; he was active from about 1890 through the 1920s. Collins operated a photography business in the South End from 1910 to 1916, and may have been employed by real estate developers to photograph new construction, not yet landscaped, in Allston, Brighton, and Cambridge.[26] He also photographed middle-class African American families and acquaintances. Of the one hundred and three portrait negatives found in his basement, forty-five carry notations that identify the sitters.

One photograph (cover), for instance, bears an inscription, "Man and Child in Garden, Hubert C. Collins 1910–1915(?)." The writing, in red ballpoint ink, is probably not that of the photographer, but this man may be a relative of Collins's. He and his child are well-dressed, and pose amidst the lush flowering foliage of a back yard. Houses and well-kept trees are visible behind the fence. Two other photographs of the same garden show a standing woman, and the same woman holding the baby seen here. Each view offers tantalizing glimpses of the garden and neighboring houses, with white curtains, trees, and trailing greenery surrounding the figures. These are not formally posed portraits taken in a studio, but a startlingly original and powerful insight into a family's environs and personality. Instead of framing stiffly posed sitters, Collins has presented an informal view of a family enclosed and almost engulfed by their urban outdoor space. The three photographs together offer a fuller view of the home and family portrayed, even if our identification is still tentative.

Collins did, however, often photograph women, children, and men inside his studio. *Mrs. Both's Baby* (fig. 10), for instance, is a formal portrait, but Collins has placed the infant beside an oversized white pillow, surrounded by the intricate webbing of a rattan chair.

The contrast of the infant's white dress and pillow with the dark chair and background, coupled with the intensely compelling gaze of the baby itself, creates a powerful composition and a portrait that far surpasses a simple baby picture. Another portrait, *Mrs. Tell's Children* (fig. 1), presents two small girls standing before the wrought iron fence of a brick house. This is a street photograph, but Collins has posed his subjects with rigid formality, so that with their black-clad feet, their white lacy dresses, and the huge white bows framing their serious faces, they seem as straight and strong as the fence posts themselves. Contrasting with the strength of the fencing and stance, Collins renders both the clothing and the ornate fencetop ornament with loving detail. As in the photograph of Mrs. Both's baby and of "Hubert C. Collins," he has combined formal portraiture with a meticulous rendering of the sitters' surroundings, as well as an appreciation for the personalities of the sitters. Collins's other figurative work includes groups of children, formal portraits of well-dressed men and women, and formal photographs of groups such as the Knights of Pythias.[27] One image presents a picnic, with three men and two women formally dressed and lounging in a park-like setting, which is probably Franklin Park. Collins's work, while clearly within the confines of studio portraiture, isolates and highlights the individuality of each sitter, and photographer and sitter comfortably occupy the same world.

Paul Rowell's 1911 photographs of Beacon Hill emerge from a completely different interaction between photographer and community. Rowell worked from 1898 to 1935 for the Boston Elevated Railway Company.[28] If Collins worked within a small world of his contemporaries and clients, Rowell photographed throughout Boston, and his work is not confined to the African American community. Some of his photographs, however, inadvertently display an enormous amount of information about the interaction of city agencies and the neighborhoods they affect, and these photographs of Lindall Place represent one of the most powerful series. The photographs chronicle the demolition of houses in a densely populated African American section of Beacon Hill, from May through December of 1911, before the building of the elevated

railway between the Longfellow Bridge (then Cambridge Bridge), and Grove Street.

Rowell's task, dating from 1897, was to record all the buildings along the proposed route of the elevated railways, and to document the construction itself.[29] Rowell shows the destruction of the buildings, and the building of the elevated structure which would bisect the small street, in a seemingly factual series of photographs that chronicle the construction month by month. Despite his position as a bureaucrat and municipal employee, a more intimate subtext to his major theme of railway construction emerges upon closer examination.[30]

Rowell frames the houses (fig. 9) so that the mostly white construction workers digging trenches in the street are directly below and in front of the black families perching on their front steps. Children seem about to fall into the trenches, with no visible signs of safety or cordoning off of dangerous areas. Yet the African American households seem to blossom around the trenches. In other photographs (fig. 11), children run through the work area, transforming a construction site into an eerie playground. Finally, Rowell records the elevated bridge which bisects this residential street, clearly stressing the victory of large-scale municipal projects over the individual families who have been displaced. Rowell was not part of this community, in the way that Collins was part of the world that he recorded, and this distance is evident in the photographs. There are very few other photographs of the African American community on Beacon Hill's North Slope or the West End.[31] However, he effectively framed the contrasts between individual life styles of the people who lived in this neighborhood and the industrial interests of the railway company.

A third turn-of-the-century photographer offers yet another context for recording the African American community. While both Collins and Rowell, however different, were professional photographers, Margaret Sutermeister was an amateur photographer living quietly in Milton. She created no fewer than eighteen hundred glass plate negatives between 1894 and 1909.[32] Her work includes many thoughtful interpretations of the Victorian values predominant in her world in Milton, but in what seems to be a conscious effort to reach out, she also documents a world far different from her own. Sutermeister's archive includes photos of Native Americans, African Americans, and other people far removed from her own middle-class existence. Among the photographs are some extraordinary portraits of African American families and individuals, possibly taken near her home.

Sutermeister's poses and family groupings, comparable in respect and dignity to those of social reform photographer Lewis Hine, are beautifully composed, and reveal the photographer's great respect for her subjects, whether poor or wealthy. Among the most moving is *Postmortem Photograph of an Infant Held by Two Women and a Girl* (fig. 2), a powerful blend of the traditional postmortem photograph and an unsettling outdoor portrait. The photographer has centered the baby's white christening/burial gown, and it contrasts vividly with its mother's darkly clad figure above. Sutermeister has placed these women directly at the corner of their clapboard house, so that the right side of the photograph, brightly lit, seems to gesture toward light and salvation, while the dark left side of the house, punctuated by the worried look of the woman on the left, looms backward in a suggestion of death and perhaps even a reference to the wood of the coffin soon to house this child. Sutermeister's interpretation is extraordinary. Other photographs are less unsettling, such as *School Wagon* (fig. 12), a horse-drawn cart full of children with their teachers, before a building that may be a schoolhouse, and several family portraits. Sutermeister may not be a part of this community, but she acknowledges the individuality of each group or family, and the strengths and tensions between sitters emerge clearly in her work.

The audience for these photographs remains unclear. Unlike Collins, who photographed for his clients, or Rowell, who worked for a single agency, we know next to nothing about Sutermeister's subjects or the uses of the photographs. Most were never printed, or the prints have been lost; only three groups of vintage prints remain.[33] It seems certain that, with the possible exception of the sitters themselves, no contemporary public ever saw them.

This exhibition does not follow the highlights of documentary photography's history exactly; for

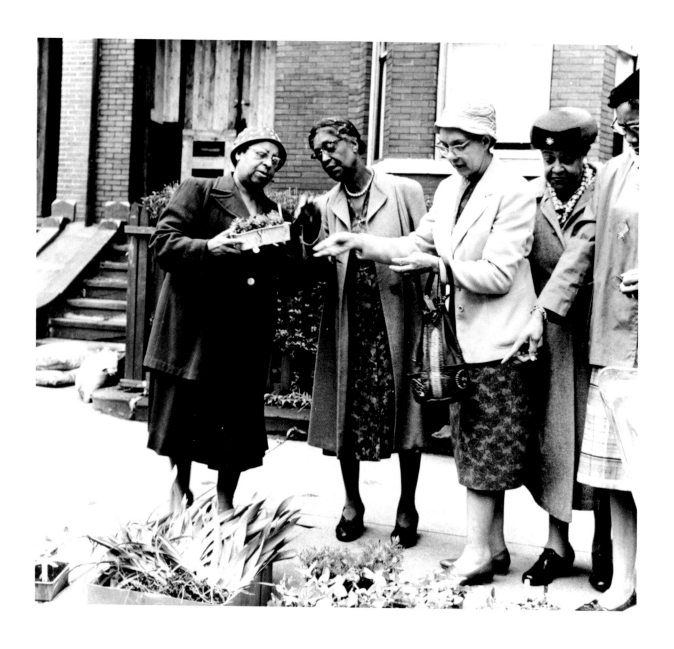

FIG. 4. Irene Shwachman, *Garden Project (Five Women)*, 1960, Freedom House Collection, Archives and Special Collections Department, Northeastern University Libraries

instance, we found no images of Boston's African American community dating from the 1930s despite repeated searches and conversations with many people. So far, photographs have been found only from the late 1940s and 1950s onward. Jules Aarons, in photographing Boston's West End, consciously followed the lead of photographers whose vision emerged during the 1930s. In the 1940s, he studied in Provincetown with Sid Grossman, who, with Siskind, was a member of the Photo League. He has stated, "I wanted to do in Boston what Helen Levitt and Aaron Siskind and Leon Levinstein were doing in New York. Photographing areas which were going to disappear."[34]

Aarons's photographs of the intermixed cultures of the West End, taken between 1948 and 1951, document the last years of one of Boston's oldest African American communities. Blacks first settled there in the nineteenth century and stayed until the area was razed by the Boston Redevelopment Authority in 1957 and 1958. Aarons, a physicist by profession, was fascinated with the relative integration of the neighborhood, which included Italian, Irish, and Jewish populations as well as African Americans. He photographed all aspects of the West End, and these photographs demonstrate the occasional events which punctuate urban life. *Conversation Piece II* (fig. 13), in its affectionate record of a lively exchange between two girls, illustrates the interracial friendships that sprang up in this community. The immediacy and graphic strength of this image is comparable to Siskind's, and formal effects vie with anecdotal detail, with humor not unlike Helen Levitt's.

Unlike Collins or even Sutermeister, Aarons had little personal contact with his subjects, although his involvement with the neighborhood extended for several years. In fact Aarons terms some of these images "sneaky photography," explaining that he used a Rolleiflex so that people would not notice him, and that he often shot decoy photographs in another direction.[35] Despite the lack of interaction with his subjects, the photographs have an emotional quality that continues to reverberate, as can be seen in *Long Shadows* (fig. 3), whose dramatic dark diagonals seem to foretell the difficult path this solitary boy might have before him. In Aarons's work, a geometric graphic

quality of the photographs replaces the limpid style of the 1930s. His dramatic highlights and exaggerated contrasts demonstrate the photographic style of the 1940s and 1950s. His is a much more personalized documentary than the turn-of-the-century images of the earlier photographers.

If Jules Aarons photographed the West End in anticipation of its demise, realizing that it was destined for drastic reshaping by the Redevelopment Authority, Irene Shwachman photographed for the other side (for the Boston Redevelopment Authority) from about 1960 to 1962. This work formed part of her larger personal documentary project, the "Boston Document," on which she worked from 1959 to 1968. Shwachman began her project, which eventually totaled more than two thousand negatives, the same year she met photographer Berenice Abbott. The premise of the "Boston Document" bears a strong resemblance to that of Abbott's "Changing New York" project. Shwachman's description of the project underlines its connection both to the recent destruction of the West End and to the tradition of urban documentary photography. "Well aware of the work of Eugène Atget in Paris and Berenice Abbott in New York, I wanted to show the upheaval caused by urban renewal, and the special quality of Boston."[36]

Shwachman worked under contract for the Boston Redevelopment during 1962, and concentrated on the Washington Park area of Roxbury. She stopped photographing the city in 1968, realizing that the press was now covering the urban changes. This project represented a combination of personal goals and contract work not uncommon for documentary photographers.[37] Shwachman's statements reveal the aspects of her project that intersected with the aims of the Boston Redevelopment Authority:

Other aspects of the work that I especially liked: the planning sessions with the BRA [Boston Redevelopment Authority]—these consisted of walking tours with one or two planners who showed me exactly what they needed: overall views of parks, buildings in conjunction with their neighbors, the spaces between buildings, the condition of the

buildings. They were especially interested in alleys and access to buildings crammed into them, in industrial sites, in groups of buildings to be considered for rehabilitation or demolition, in play areas, the elevated tracks, blocks of stores.[38]

Photographs like *Bower Street* and *Palm Sunday* (fig. 14) illustrate the interaction of personal and municipal interests in a much more self-conscious way than Rowell's photographs do. In discussing the Redevelopment Authority project, Shwachman comments, "Alpine and Regent Streets were on the list, and it was at that time that I found the two young girls who had hung their swing from the street sign standard."[39] *Palm Sunday* is only one of an entire contact sheet of these girls playing on their swing.

In addition to her Redevelopment Authority work, Shwachman made a number of pictures for Freedom House, a Roxbury community and cultural center founded by Muriel and Otto Snowden. In 1960 Freedom House sponsored a garden project with Wellesley's Garden Club, and *Garden Project (Five Women)* (fig. 4) is a part of that series. Her attention to the interactions among these women respects their friendship without intruding, formally or socially, on their conversation. Shwachman's photographs of this project highlight the vibrant community of individuals in their neighborhoods. Aarons and Shwachman still partially believed in the transparent photographic style of the 1930s, and in the storytelling power of the photographic documentary tradition, although their work dates from the 1940s through the early 1960s.

By the late 1970s and 1980s, however, documentary photography took on another series of meanings. In an era when photography is taught in art schools, and postmodern theory is an inevitable part of any artistic or journalistic practice, many photographers continue to believe in the power of documentary photography, but in a much more self-conscious manner. Polly Brown teaches documentary photography at the Art Institute of Boston, and her own involvement with the city of Boston as well as her teaching reflects this awareness. Brown clearly describes the personal framework through which any project must be understood:

Documentary photography is a way of learning about the world by photographing it. A simple concept maybe, but we human beings tend to be a provincial lot, defining ourselves by the parameter of our friends and rituals that orient us in our own existence.[40]

Brown has been photographing Boston neighborhoods since her involvement with the "City Limits" project, an urban photographic essay by four photographers begun in 1985. Her photographs of Mattapan and Roxbury incorporate the cultural context of the subjects, and demonstrate her sophisticated understanding of a neighborhood as a "social and moral concept." As Kelly Wise writes in the introduction to the book, "Communal feelings in a number of these neighborhoods are engendered in part by shared activities, ethnic rituals, and annual events."[41] Brown's ongoing involvement with these communities highlights these social rituals, honing in on celebrations, church rituals, and social centers, though she is conscious of her role as invited guest or spectator rather than family member in each case. *Fourth of July, Mattapan* (fig. 15) and *Barber Shop, Roxbury* (fig. 5) frame these events in a celebration of normalcy, neither monumentalizing nor isolating, but reinforcing the relations between photographer and subject. Brown avoids an overarching goal, such as Shwachman's attempt to record all of Boston, and concentrates instead on the interactions and physical postures of these community members as they share their meals and Saturday haircuts with her.

Beverly Conley shares Brown's awareness of the contextual position of the photographer, but immerses herself even more deeply in a community at first foreign to her. During several years in Dorchester, Conley became involved with and began to photograph the Cape Verdean community in Roxbury and Dorchester. This community, with its unique blend of Portuguese and African cultures, was very closed, and she began her project in 1987 with an introduction from Father Pio, the priest for Saint Patrick's Catholic Church. Conley gradually steeped herself in Cape Verdean history and culture, and in 1990 even visited the Cape

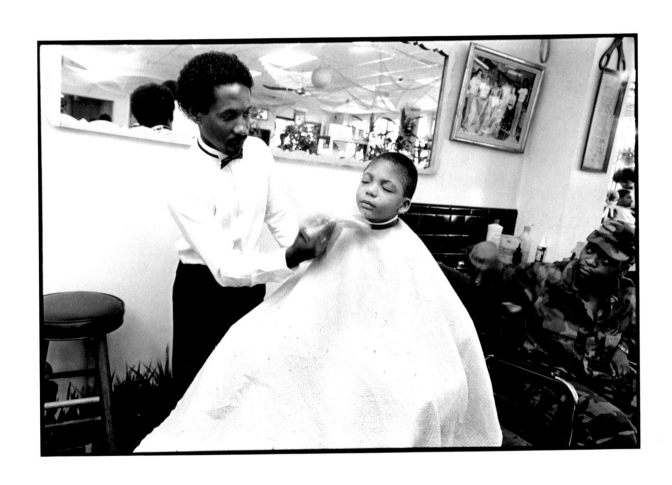

FIG. 5. Polly Brown, *Barber Shop, Roxbury*, 1985, Collection of the artist

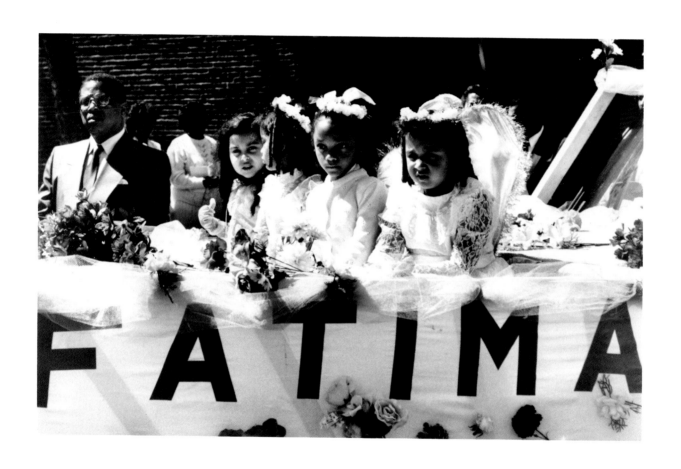

FIG. 6. Beverly Conley, *Angels in Our Lady of Fatima Procession, Roxbury*, 1989, Boston Public Library, Print Department

Verde Islands located off the African coast.[42] As she gradually met more families, she began to document the culture's survival in Boston, and the clash between the more Americanized younger generation and their parents.

Despite the traditional link between the cranberry industry and the Cape Verdeans, Conley concentrates on the individual families and their Catholic identity. Photographs such as *Angels in Our Lady of Fatima Procession, Roxbury* (fig. 6) present the Mother's Day procession of small girls on their float during the community parade. These children, in their First Communion dresses, are framed against the bricks and clapboards of their houses, so that the contrasts between New England architecture and the Catholic religious ceremony, between African and American, and between new and old generations, are subtly revealed. Conley also highlights the strength of these women in their communities in more private domestic views such as *Bernadette and Benvinda Teixeira Helping with the Laundry* (fig. 16).

Brown and Conley document distinct sectors of the African American community as visitors, although they meticulously express the subtle differences in each family or personal unit. In contrast, Lou Jones photographs in color his own community and the areas surrounding his commercial studio. Jones participated in the Orange Line Project "Along the El," but the photographs in this exhibition were often taken while working on assignment for clients. Jones describes them as poetic moments "that accompanied a client's prose."[43] Rather than isolating individual families or social settings, Jones's color photographs highlight specific activities, like basketball (*Graffiti Basketball*, fig. 17) or children playing in summer fountains (*Fountain*, fig. 7). The subjects explode with physical movement, and the vibrant hues create a kaleidoscopic effect. The photographs celebrate street life, but the violently colored patterns of graffiti and spraying water suggest the transient quality of these communities, creating an enduring photographic document from temporary moments rather than from mortar and stones. Like Rowell, Aarons, and Shwachman, Jones is conscious of the need for photographers to record passing events: "We must bear witness while it's there because then it is history."[44]

Hakim Raquib also photographs his own commu-nity. In his work, Raquib consciously creates powerful formal imagery of diverse cultural events, using the medium as "an aesthetic means of expression that reflects the spirit of our times, and to provide diverse viewpoints that draw from and bridge a broad range of cultural traditions."[45] He often zeroes in on a specific event in great depth, as in his *Canvas Cathedral* series (*On the Sabbath, Canvas Cathedral, Roxbury*, fig. 18). Like those of Collins, his prints highlight the luminous contrasts of black and white forms, as seen in the white robe and bathing cap of a woman (awaiting immersion) against the darker tones of her skin. Raquib's series follows the various stages of the Seventh Day Adventists' revival, an annual event near Jackson Square in Roxbury. By documenting the progression of the baptism candidates through preparation, prayer, and immersion, Raquib's luminous photographs capture some of the spirituality of the event he records. The graphic highlights of his prints also dominate another neighborhood series, the photographs Raquib took in Orchard Park and Fort Hill. *White Picket Fence: Fort Hill* (fig. 8) frames a black teenager against a tall white picket fence, emphasizing the contrasts between the architectural details of this prerevolutionary area and the details of the boy's clothing and stance.

Although a history of Boston's African American documentary photographs cannot be written in a linear, factual mode, these fragments illuminate important points along the line. Whether documenting men or women, exteriors or interiors, static or moving subjects, these nine photographers frame the city of Boston as a particularized community. No grand generalizations are possible, but the individuals photographed by each photographer are seen in an intertwined cultural context. Out of this web emerges a definition of community that unites very disparate photographers. Collins, Rowell, and Sutermeister worked in an era that believed in the transparent truth of the photograph, Aarons and Shwachman manipulated that concept of truth to personalize the city, while Brown, Conley, Jones, and Raquib admit the impossibility of grand photographic truths while celebrating individual moments in the city's cultural and social fabric.

In this partial history of Boston's African American photographic archive, the fragmentary nature of the

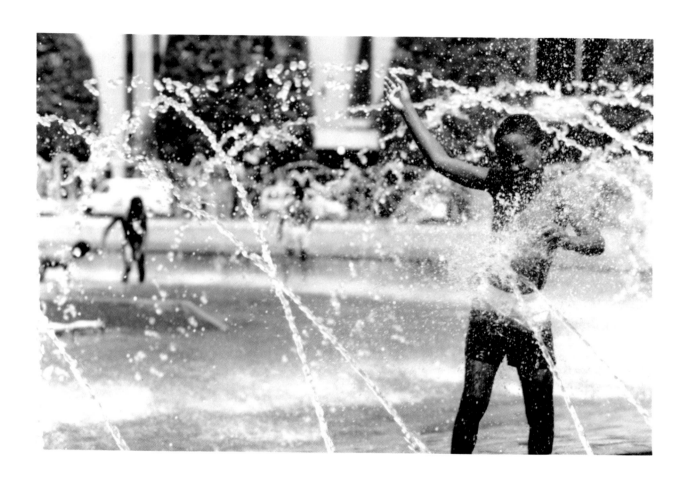

FIG. 7. Lou Jones, *Fountain*, July 1988, Collection of the artist

material is a given. Both the creators and the consumers of culture are players in this drama. There is no single voice and no single style that dominates the field; multiple kinds of photography demand to be seen. Yet this is no handicap, but rather a sign of a vibrant and active writing and reading of documentary photography. The interactions between culture and community, poser and photographer, and image and viewer become part of a complex web of meanings that attempts no total overview, but rather a series of in-depth glimpses of the African American community over time.

NOTES

1. Alan Trachtenberg, *Reading American Photographs: Images as History, Mathew Brady to Walker Evans* (New York: Hill and Wang, 1989), p. xvi.

2. In 1937, Siskind and seven other photographers, Harold Corsini, Lucy Ashjian, Beatrice Kosofshy, Richard Lyon, Jack Mendelson (Manning), Sol Prom (Fabricant), and Morris Engle, began a project, the "Harlem Document," which was planned to describe different sides of the Harlem community. Begun in collaboration with Michael Carter, an African American sociologist, it was completed in 1940, and was exhibited and partially published in *Look* and *Fortune*. A selection of Siskind's photographs for the project were published in 1981 as *Harlem Document: Photographs 1932–1940.* (Maricia Battle, "Harlem, A Document," *Harlem Photographs 1932–1940: Aaron Siskind*, Washington: National Museum of American Art, Smithsonian Institution, 1990, p. 3–4).

3. *Photo Notes*, August 1938, reprinted in *Harlem Photographs 1932–1940*, 1990, p. 4.

4. *Ibid.*, p. 6.

5. Aaron Siskind, "The Drama of Objects," *Minicam Photography* (June 1945), reprinted in *Harlem Photographs 1932–1940*, pp. 5–6.

6. "Harlem Photographs 1932–1940: Aaron Siskind" was originally organized in 1990 by Washington's National Museum of American Art, Smithsonian Institution.

7. Current scholarship on documentary photography in the 1930s includes: Pete Daniel, Merry Foresta, Maren Stange, and Sally Stein, eds., *Official Images: New Deal Photography* (Washington, D.C.: Smithsonian Institution Press, 1987); Carl Fleischhauer and Beverly Brannan, eds., *Documenting America* (Berkeley: University of California Press, 1988); Nicholas Natanson, *The Black Image in the New Deal: The Politics of FSA Photography* (Knoxville: University of Tennessee Press, 1992); John Rogers Puckett, *Five Photo-Textual Documentaries from the Great Depression* (Ann Arbor: UMI Research Press, 1984); Maren Stange, *Symbols of Ideal Life: Social Documentary Photography in America: 1890–1950* (New York: Cambridge University Press, 1989); William Stott, *Documentary Expression and Thirties America* (New York: Oxford University Press, 1973); and Alan Trachtenberg, *Reading American Photographs: Images as History, Mathew Brady to Walker Evans* (New York: Hill and Wang, 1989).

8. Although applied in a more generalized fashion here, the phrase "homeplace" stems from Bell Hooks's assertion that women's "working to create a homeplace that affirmed our beings, our blackness, our love for one another, was necessary resistance." Bell Hooks, "Homeplace, A Site of Resistance," *Yearning: Race, Gender and Cultural Politics* (Boston: South End Press, 1990), p. 46.

9. Robert Hayden, *African-Americans in Boston: More Than 350 Years* (Boston: Boston Public Library, 1991). Also see James Oliver Horton and Lois E. Horton, *Black Bostonians: Family Life and Community Struggle in the Antebellum North* (New York: Holmes & Meier, 1979). For a more detailed discussion of the West End, see *The Last Tenement: Confronting Community and Urban Renewal in Boston's West End* (Boston: The Bostonian Society, 1992).

10. For a clear overview, see the Bicentennial publication *Black Bostonia: Boston 200 Neighborhood History Series* (Boston: The Boston 200 Corporation and the Boston Public Library, 1976).

11. James Clifford, "Introduction: Partial Truths" to *Writing Culture: The Poetics and Politics of Ethnography* (Berkeley: University of California Press, 1986), p. 22.

12. Maren Stange, *Symbols of Ideal Life: Social Documentary Photography in America 1890–1950* (New York: Cambridge University Press), p. xiv.

13. Alan Trachtenberg, "From Image to Story: Reading the File," *Documenting America 1935–1943*, eds. Carl Fleischhauer and Beverly W. Brannan (Berkeley: University of California Press, 1988), p. 45.

14. Trachtenberg, "From Image to Story," *Documenting America 1935–1943*, p. 70. Nicholas Natanson has written specifically about the issues of documentary photography and the representation of African Americans in the 1930s. See Nicholas Natanson, *The Black Image in the New Deal: The Politics of FSA Photography,* 1992.

15. Guy C. McElroy, "Introduction: Race and Representation," *Facing History: The Black Image in American Art 1710–1940* (San Francisco: Bedford Arts and the Corcoran Museum, 1990), p. xi.

16. Angela Davis, "Photography and Afro-American History," in Valencia Hollins Coar, ed., *A Century of Black Photographers 1840–1960* (Providence: Museum of Art, Rhode Island School of Design, 1983), p. 27.

17. Valencia Hollins Coar, "Introduction," *A Century of Black Photographers: 1840–1960*, pp. 9–14.

18. See Deborah Willis-Thomas [Braithwaite], *Black Photographers, 1840–1940: An Illustrated Bio-Bibliography* (New York: Garland, 1985) for the most complete overview of these photographers to date. One thousand of Smith's glass plates have resided in the Museum of Afro-American History, Boston, since 1973.

19. Smith was an amateur photographer who documented family, friends, and surroundings in both cities. He was the first black graduate of the Boston University Law School, and also held a degree from Howard University Dental School.

20. Many thanks to John Mitchell and the Massachusetts Audubon Society for leading us to Gilbert's work.

21. See Deborah Willis-Thomas [Braithwaite], *An Illustrated Bio-Bibliography of Black Photographers, 1940–1980* (New York: Garland Publishing, 1989). Exhibitions she has curated include "America: Another Perspective," NYU Tisch School of the Arts,

Photo Center Gallery, February 1986; and "Convergences: Eight Photographers," Photographic Resource Center, Boston, 1990. *Songs of My People* (Boston: Little, Brown, 1992) is another recent anthology of fifty-three black photographers given assignments of one week each from June 3–June 10, 1990.

22. See Deborah Willis-Thomas [Braithwaite], *An Illustrated Bio-Bibliography of Black Photographers 1940–1988,* 1989.

23. Kelly Wise, "Introduction," *City Limits: Images of Boston in Transition* (photographs by Roswell Angier, Polly Brown, Bill Burke and Kelly Wise), (Boston: Northeastern University Press, 1987), p. xii.

24. Organized by UrbanArts, Inc. and Boston's MBTA, this presentation included contemporary photographers James Culler, Zaid Aoude, Linda Swartz, Melissa Shook, John Lueders-Booth, Lou Jones, and David Akiba.

25. Brian Palmer, "Reviews," *Afterimage* (February 1991), p. 15.

26. Thanks are due to Representative Byron Rushing for sharing his knowledge of Herbert Collins, and his photocopies of prints from the collection of glass plate negatives. The negatives are now housed at the Museum of Afro-American History, Boston.

27. Sitters include an A. Cuper, Mrs. Ward, two portraits of Mrs. Vassell, Mrs. Leahr, Miss Bailey, Beatrice Collins, Mr. Collins.

28. See an unpublished essay by Frank Cheney, in the files of the Boston Transit Commission Archives, Society for the Preservation of New England Antiquities.

29. The Boston Elevated Railway Company formed part of the transportation boom at the turn of the century. It was overseen by the Boston Transit Commission, which had been created by the Massachusetts Legislature in 1894 to design and build the first subway tunnel for electric streetcars under Tremont Street and the Boston Common. The Commission also supervised and leased the subway line to the West End Railway Company, a merger of Boston's four existing horse railways in 1887. In 1897 the Boston Elevated Railway Company acquired the West End Railway Company, and set out to build elevated railways, including this one, which would connect to the subways built by the Boston Transit Commission.

30. Similar multiple meanings have been read in Eugène Atget's Paris photographs from 1889–1927, in Molly Nesbit's *Atget's Seven Albums* (New Haven: Yale University Press, 1992).

31. Other single images of this neighborhood include a photograph of the African Meeting House from the late nineteenth century, in the collections of the Boston Athenaeum, and a pair of photographs of Washington Court, also at the Athenaeum.

32. For a complete discussion of Margaret Sutermeister, see Judith Bookbinder, *Margaret Sutermeister: Chronicling Seen and Unseen Worlds 1894–1909* (Milton: Milton Historical Society, 1993).

33. One box of photographs was given to the town of Milton in 1904 by James Munson Barnard, and two albums survive from Sutermeister's home in Milton. (Bookbinder, *Margaret Sutermeister,* pp. 5–6).

34. Conversation with the artist, October 10, 1993.

35. *Ibid.*

36. Irene Shwachman, "The Boston Document," unpublished project description, Freedom House Collection, Archives and Special Collections, Northeastern University Libraries.

37. For example, a total of one hundred and twenty prints were acquired by Walter Muir Whitehill for the Boston Athenaeum, over a number of years, in a patronage project not dissimilar to that of Eugène Atget in Paris, who sporadically sold prints from his larger project to various city institutions.

38. Shwachman, "The Boston Document."

39. *Ibid.*

40. Artist's statement.

41. Kelly Wise, "Introduction," *City Limits,* p. xii.

42. See Beverly Conley, "In Focus: Cape Verde in the Americas," *Class* (March/April 1993), pp. 24–25.

43. Artist's statement.

44. *Ibid.*

45. Artist's statement.

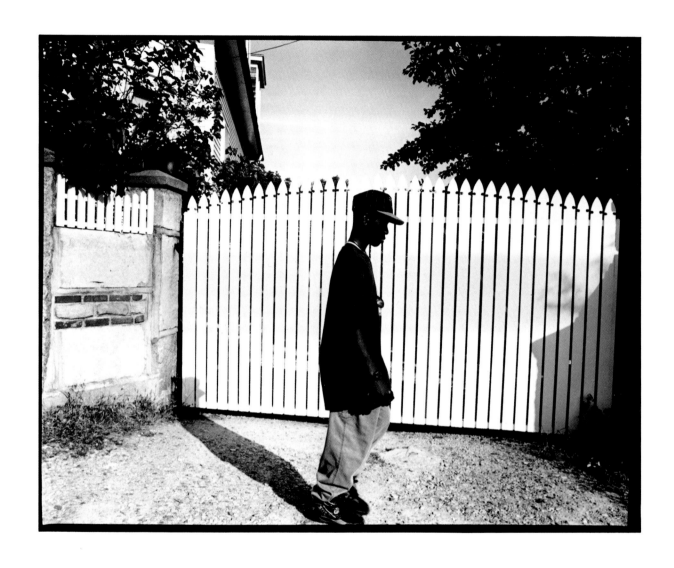

FIG. 8. Hakim Raquib, *White Picket Fence: Fort Hill*, 1992, Collection of the artist

EDMUND BARRY GAITHER

At the turn of the century, Boston's black community, though small (numbering only 11,300 in 1910), was regarded as progressive and nationally important. Its nineteenth-century heritage was strongly associated with such racially crucial struggles as emancipation and social justice. Boston had been Frederick Douglass's launching pad when he assumed leadership of the abolitionist movement, and it was now home of William Monroe Trotter, who was reshaping early twentieth-century protest in a more nationalistic direction. Blacks throughout the country saw Boston as a beacon, a guiding light in the fight for full freedom and equality, and Bostonians held no lower vision of themselves.

Boston expressed its aspirations through publications such as the *Colored American Magazine* (begun in 1900) and the *Boston Guardian* (launched in 1910). The city was also haven to many small black-owned businesses including several hotels, the Eureka Cooperative Bank (est. 1910),[1] and was the northern center for the work of the National Negro Business League. Impressive for its reputation as a place sympathetic to black educational and cultural ambitions, Boston attracted many gifted southerners as well as a steady flow of West Indians, all seeking enhanced opportunities for personal development.

In the South, Boston was perceived as the best location for brilliant blacks who had graduated from such noteworthy black institutions as Atlanta or Fisk Universities. Such was the attraction that led Edwin Augustus Harleston, after completing studies in Atlanta, to Harvard University and later to the School of the Museum of Fine Arts in 1905.[2] The same perception led Martin Luther King, Jr., and his future wife, Coretta, both from Atlanta, to Boston University and the New England Conservatory of Music forty years later. Roland Hayes, a Georgian, also found Boston the place to realize his dreams, again completing the axis between key southern centers and "beantown."

The city's ability to attract national talent was, of course, not limited to areas south of the Mason-Dixon line. Boston drew as well from northeastern cities that, before World War I, were Boston's rivals for black urban celebrity. As the South End became a new, compact, black community resulting from the shift of African Americans from their earlier neighborhood on Beacon Hill, West Indian immigration swelled its ranks. By 1913, West Indians were numerous enough to establish St. Cyprian's Episcopal Church as a primarily Caribbean congregation. Their lingering identification with the West Indies distinguished them from the Churches of St. Augustine and St. Martin, which had been established only five years before by black Episcopalians. Churches then, as now, were central pillars of the black community, providing not only religious guidance but also extended social and cultural services. Yet within Boston's tightly knit black community, they were not adequate to meet the sum of social needs, as newcomers arrived in increasing numbers. Other organizations were required, such as the Harriet Tubman House, founded in 1904 by several black women, or the Plymouth Hospital, which provided medical services from 1908 to 1928. Continuing at the forefront of the struggle for civil rights, Boston organized the first chapter of the National Association for the Advancement of Colored People (NAACP) in the United States in 1910. And in 1911, William Monroe Trotter, unsympathetic to the integrationist stance of the NAACP, launched his Equal Rights League. Boston was still at the heart of America's black agenda.

Boston was a leader in cultural affairs as well. For example, in 1910, greater Boston became home for Meta Warrick Vaux Fuller,[3] America's foremost black sculptor after the death of Edmonia Lewis, who herself had spent time in Boston in the 1860s. If any image of how Boston's black community saw itself in these early years of the century was sought, that image might very well be captured in Meta Warrick Vaux Fuller's 1913 *Emancipation,* a sculpture created at the urging of Dr. William E. B. DuBois in celebration of

the fiftieth anniversary of the Emancipation Proclamation.[4] Heroic in scale, *Emancipation* is the nation's only memorial marking the end of slavery presented from the viewpoint of the freedman. In an article on emancipation monuments, early art historian Murray Freeman[5] discusses Fuller's sculpture, heaping upon it as much praise as he gave Augustus Saint Gaudens' *Robert Gould Shaw Monument* (featuring the Massachusetts 54th regiment, of Civil War fame) opposite the State House. *Emancipation* underscored Boston's place as a progressive cultural, educational, and political center in dialogue with other black communities throughout the United States.

This view of Boston was to change considerably after World War I. While Bostonians were to retain their celebrated notion of themselves, national attention was shifting dramatically toward the newly emerging mega-communities of African Americans in Washington, Baltimore, Cleveland, Pittsburgh, Detroit, and especially New York and Chicago. Boston's black population of perhaps 30,000 was now small compared to Chicago's 103,000 or New York's 110,000. Increasingly, national black leadership came from larger centers where numbers were being translated into political power through virtually all-black wards, districts, and precincts.

Nevertheless, Boston participated in the changing consciousness that swept black communities in the Negro Renaissance era. It had a very active Universal Negro Improvement Association, Marcus Garvey's politico-economic enterprise. Its two papers, the *Boston Chronicle* (1920–1967) and the *Boston Guardian*, continued to foster lively debate regarding appropriate models for community and race advancement. And on the cultural front, Boston held its own for quality, if not for quantity.

Women in Boston's black community became leaders in aiding the transition of newcomers from the South and the Caribbean. In order to better meet the demand for social services, groups such as the League of Women for Community Service and the Women's Service Club sprang up, and from them came such towering figures as Melnea Cass, who is remembered for doggedly pursuing social justice and civil rights despite obstacles.

Over the course of the twenties and thirties, in addition to earlier artist groups such as the Boston Negro Artist Club (est. 1907), Boston had several black theatrical and musical organizations. The Negro Repertory Company and the Boston Stage Society as well as the Allied Artist Group were producing plays and musicals such as *Emperor Jones*.[6] Jazz greats made Boston a regular stop, and gifted local musicians such as Sabby Lewis started their own bands, as early as 1937. James Guilford, a Boston barber whose establishment served black entertainment notables for decades, remarks that Boston was a "great jazz town" in those days.[7]

Roland Hayes, one of the most-celebrated early classical concert singers, made his career in Boston, where he performed in Symphony Hall as early as 1917. A tenor of extraordinary interpretation, Hayes brought Negro spirituals to the international stage, including command performances at Buckingham Palace before English royalty. Harry T. Burleigh, an arranger of Negro spirituals, also frequented Boston and Martha's Vineyard in the twenties and thirties.

As awareness of the artistic heritage of blacks grew with the embrace of southern (folk) and African sources, black communities sought to inspire their youth through greater self-knowledge. Several Boston black women founded the Aristo Club in 1924 to foster appreciation of cultural knowledge. They anticipated by two years the launching of Negro History Week by Carter G. Woodson and the creation of the Association for the Study of Negro Life and History in Washington in 1926. Young African Americans of the late twenties, such as Lois Mailou Jones, were aided in their career choices by encounters with Boston personalities such as Charlotte Hawkins Brown,[8] who established Palmer Memorial Institute in Sedalia, North Carolina. Jones went to teach for Ms. Brown at Palmer after hearing her speak at a Ford Hall Forum.

The paintings of Allan Rohan Crite powerfully portray the image of Boston's black community in this period. Rejecting exotic jazz representations which falsified and glamorized urban black nightlife, and denying the widespread characterization of southern blacks as rural illiterates, Crite depicted his South End neigh-

borhood as at peace with itself and engaged in the ordinary pursuits of the day. In some paintings, people were shown going to church; in some, they were fraternizing in front of the Hi-Hat Club; in others, children were playing in the streets as neighborhood preachers attempted conversions nearby. From the overall quality of the scenes, one learns that the black community was intact, wholesome, and engaged in its own business. By the mid-forties, Crite was lamenting the loss of this quality of community cohesion and unity of purpose, for with the passing of the era of cotillions and teas went the notion of the community as essentially monolithic.

The period stretching from the end of World War II to the rise of the Black Power cries of the sixties saw major transformations in Boston's black community, transformations in both its actual makeup and its self-perception. As population increased from 23,000 in 1940 to 63,000 in 1960, the city received not only its previously acknowledged flow of Caribbean blacks, but also became home to a rapidly rising population of southern blacks. By 1970, 51 percent of Boston's black population was born outside of Boston and 29 percent were from the South.

The majority of these new southerners came from further down the social ladder. Indeed, most of those heading to Boston—like their forerunners to midwestern and eastern cities after World War I—were from lower economic stratas. Like those forerunners, they, too, were searching for economic betterment and enhanced educational opportunities.

The swelling of Boston's black community in the fifties and sixties challenged and activated latent racism in the city, leading to the mini-riots of the late sixties and the busing crisis of the seventies. In fact, Boston in the mid-seventies looked remarkably like Little Rock, Arkansas, in the fifties.

In the post–World War II era, this once small and unified community had to adjust to militant new voices putting forth views ranging from Malcolm X's "separatist" Nation of Islam to U.S. Senator Brooke's well-reasoned legalism. In between were advocates of direct action, black capitalists, integrationists, assimilationists, economic nationalists, and the like. As other cities began to convert their numbers into

During the thirties there was in the Boston community of blacks a black society, that is, . . . a group of those in the professsions, educated and . . . elite. There were . . . "coming out parties" for debutantes . . . and the whole apparatus of a society group. The income level was high, and there was an attitude towards those of no "social standing" of a sense of difference. . . .

There was, however, in this social class . . . a very real interest in equal rights . . . and . . . civil rights, and so there was a great deal of work . . . which was a foundation of later development.

After World War One, . . . change in the black community started, namely a . . . slow migration from the south. This accelerated considerably during World War Two, so that the close knit black community of the early thirties [and] . . . forties disappeared. The influence of social class of the earlier period diminished and finally vanished.

The earlier black community was held together . . . by two periodicals, . . . the Chronicle *[and] the* Guardian. . . . *The impact, however, of several items: massive dislocations because of urban renewal, massive migrations into Boston, . . . the disruptions of the war, resulted in the demise of these two papers, which . . . represented an end of an era . . . which to me . . . seems so very, very long ago.*

—Allan Rohan Crite, "An Autobiographical Sketch," unpublished manuscript, Boston, 1976.

political power, Boston and the Bay State, which had pioneered with the election of a black U.S. senator, seemed unable to elect a mayor even with a rainbow coalition. A new intracommunity dialogue was in the process of difficult birth.

The forties, fifties, and early sixties were recorded, like earlier periods, by artists. Foremost among them were Calvin Burnett and John Wilson, both of whom painted street and genre scenes of greater Boston. Wilson, who grew up in Roxbury and studied at the School of the Museum of Fine Arts, depicted riders on the Orange Line and neighbors in Madison Park, as well as Roxbury rooftops. Burnett, who grew up in Cambridge and studied at the Massachusetts College of Art, painted haunts where musicians gathered and nightlife thrived. Yet both painters, reflecting the more critical and angry mood regarding race relations that was emerging in the country, also created works such as *Native Son,* inspired by Richard Wright's novel, and *Trial,* recalling the Scottsboro case (both Wilson), or *They That Carried Us Away Demand of Us a Song* (Burnett).

Boston's tendency toward leadership in education and culture was to bring it into prominence again in the third quarter of the century. The Elma Lewis School of Fine Arts, an institution for middle-class black children in Roxbury, opened in 1950, bearing the name of its founder, a gifted visionary and educator who, having grown up in Roxbury in a Garveyite family, wished to shape the character of sharp black youngsters through the arts. Through the efforts of the students and their parents, the school was self-supporting, offering instruction in dance, music, art, and theatre. In 1968, a companion institution, the National Center of Afro-American Artists, was founded by Elma Lewis, and shortly thereafter brought to Boston many remarkable and nationally recognized artists including Nigerian drummer Michael Babatunde Olatunji and choreographer/dancers Talley Beatty and Billy Wilson. For a decade or more, it presented to Boston's black community annual appearances by Duke Ellington, Odetta, and others of near-comparable stature. Eyes from across the nation were again looking to Boston for guidance in putting together an integrated, multidisciplinary model of a black cultural center.

Particularly interesting were developments in the visual arts. In the wake of the creation of the *Wall of Respect* in Chicago in 1968, a Boston group of artists led by Dana Chandler and Gary Rickson established a mural movement in Boston. By the early seventies, more than a dozen large, outdoor paintings by black artists had been executed, and Boston was being cited as a leading location for politically inspired "black art." Nelson Stevens is one of the several artists whose careers first came to attention via murals and who have become masters in this medium. Others, such as Alfred Smith and Arnold Hurley, initially associated with Boston murals, now work in distant cities where they still evince Boston's impact.

In 1970, the Museum of Fine Arts presented what was at that time the largest and most critically well-received exhibition of works by African American artists within the context of a major American museum. When I organized "Afro-American Artists: New York and Boston" I was one of very few blacks on the curatorial staff of a top American art museum. The show was co-presented by the Museum of the National Center of Afro-American Artists. Covered by the *New York Times, Artsmagazine, Newsweek,* and other national publications, "Afro-American Artists: New York and Boston," eclipsed the Metropolitan Museum of Art's "Harlem on My Mind" which, after all, could hardly be described as a fine arts exhibition.

The Museum of the National Center of Afro-American Artists was one of a growing number of museums committed to black heritage and inspired by the black consciousness movement of the sixties. Though begun in the fall of 1969, it was not Boston's first such institution. In 1964, a group of Boston educators and social activists had launched the Museum of Afro-American History, which was later to acquire the African Meeting House on Smith Court, Beacon Hill. The Museum of Afro-American History, focusing on regional sociopolitical history and documentation, counts among its early supporters Sue Bailey Thurman, wife of Boston University theologian Howard Thurman; Meta Warrick Vaux Fuller, sculptor; James Marcus Mitchell, artist and educator; and Byron Rushing, formerly director and presently a member of the Massachusetts House of Representatives. Boston's museums are among the

earliest non-university black museums in the nation, preceding those of Philadelphia, Los Angeles, Dallas, and Atlanta.

Reflecting on life in Boston's black community over this century, one is struck by the engagement with large issues—equality, racism, education, economic development, and the like. Yet such engagement was only one aspect of community life. Simultaneously, as the photographs in this exhibition reflect, African American children were growing up playing in the streets and on vacant lots; caring adults were organizing programs—little leagues, and the like—on their behalf; ladies were going to church and attending their club meetings; old men were discussing politics in barbershops and parks; and young couples were trying to buy homes and raise families. In short, everyday life was proceeding with a sense of hope and practical self-application.

Given its ever-increasing complexity, the Boston African American community no longer wears a single face. Photographers, painters, sculptors, moviemakers, videographers, dancers, all now present different facets of the identity of black Boston. The constellation of the works of these myriad imagemakers captures the splintered, even fractured, vision of the various neighborhoods where African Americans live in the city. With its competing intracommunity interests, Boston has become a cauldron, a crucible forging a substantially different future for itself as it strives to come to grips with violence and familial dislocation, sharply drawn economic stresses, harsh racism, and the flight of many of its more gifted citizens to the suburbs. Nor has media, with its amazing power to distort or inform, helped African Americans in Boston gain a clear picture of themselves. As we come to the end of the century, the Boston black community, like every other community, has entered a period of reassessment, of redefinition, and ultimately, of reconstruction. The images of photographers and artists over the century may help in this process by providing visual points of reference for who we have been.

People today are naive about Boston. Boston has a set of prejudices that are dangerous. It's like (trying to) go through a plate-glass window. They'll tell you to go through, and when you get there you can't get through. . . . Boston has always been, and I'm sorry to say, always will be a racist city. And I was born here and raised here and I've had it all.

—Mrs. Beryl Roach, from *Lower Roxbury: A Community of Treasures in the City of Boston,* edited by Ronald Bailey, 1993.

NOTES

1. All population figures for Boston as well as dates for the establishment of Boston organizations are taken from Robert Hayden, *African-Americans in Boston: More Than 350 Years* (Boston: Boston Public Library, 1991).

2. *Edwin Harleston: Painter of an Era, 1882–1931,* (Detroit: Your Heritage House, 1983, pp. 12, 30). This short monograph offers a lively discussion of the coterie of educated, professional southerners who befriended Harleston while he was in Boston.

3. *An Independent Woman: The Life and Art of Meta Warrick Fuller* (Framingham: The Danforth Museum, 1984, p. 4 ff).

4. *Against the Odds: African American Artists and the Harmon Foundation* (Newark: The Newark Museum, 1989, p. 18).

5. Murray Freeman, "Emancipation and the Freed in American Sculpture" (Washington, D.C.: self-published, 1916).

6. Allan R. Crite, "An Autobiographical Sketch," unpublished manuscript, Boston, 1976.

7. From an interview with James Guilford conducted by the author in the summer of 1993.

8. *Reflective Moments: Lois Mailou Jones* (Boston: Museum of Fine Arts, 1973, unpaginated).

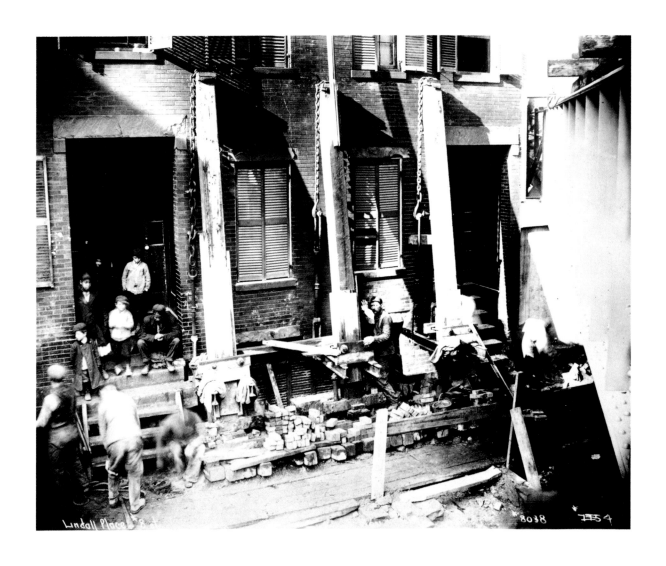

FIG. 9. Paul Rowell, Boston Elevated Railway Company, *8 Lindall Place, Boston*, November 11, 1911,
Society for the Preservation of New England Antiquities

AFRICAN AMERICANS IN BOSTON: A DEMOGRAPHIC SURVEY

In 1638, eight years after the city's original settlement, the first enslaved Africans arrived in Boston on a merchant vessel named the *Desire*, which carried cotton, tobacco, and slaves from the Bahamas.[1] By 1644, Boston slave-traders had begun importing "gold dust and negroes" directly from Africa.[2] The first African American landowner in Massachusetts may have been Bostian Ken, whose property in 1656 included a house and lot in Dorchester, as well as four acres of wheat.

After Massachusetts abolished slavery in 1780, a small African American community grew up in the West End of Boston. According to the first United States census of 1796, African Americans numbered 766, comprising 4 percent of the Boston population. By 1800, the number had reached 1,100, making Boston's one of the largest free African American communities in North America.

In the nineteenth century, most of Boston's African American residents lived in the district now called the north slope of Beacon Hill, between Pinckney and Cambridge Streets and between Joy and Charles Streets. The prevailing easterly winds made this area unappealing to the upper-class residents of Beacon Hill. Overcrowding in the North End, where many African Americans lived, also spurred migration to the West End.

In 1806, free blacks in Boston raised $7,000 and established the African Meeting House on Beacon Hill. It was built by black craftsmen and laborers. The Meeting House performed many social and religious functions and served as an "anchor" for African American settlement here. By 1860, the narrow streets and small apartments on the north slope housed almost two-thirds of Boston's black population.

During this period, the West End became more ethnically diverse. An influx of Irish, Italian, Polish, Russian, and other European immigrants settled in the neighborhood, attracted by its proximity to industry. In the 1870s, single-family dwellings gave way to boarding houses and brick tenements constructed along blind alleys and courtyards. By the end of the nineteenth century, the overall population density of the West End was second only to the North End, and the number of black residents had risen to 8,125.

Around 1890, African Americans started to leave Beacon Hill and move to the South End. By 1920, this migration was almost complete. At the time of the destruction of the West End in the late 1950s by the Boston Redevelopment Authority, only a few black families lived there, although their community remained closely knit. While African American residents in the West End often lived in the same buildings as working-class whites, social segregation prevailed.

During the first half of the twentieth century, the entire South End and Lower Roxbury community became "the traditional and historic" African American section of Boston.[3] Until 1950, most black residents occupied the narrow geographical strip bounded by Columbus Ave., Washington St., Dartmouth St. and what is now Dudley St. There was tremendous growth in the local black population after World War II, with many families moving up from the southern states. Between 1940 and 1960, the population increased from 23,000 to 63,000. At this time, African American families moved into upper Roxbury, Dorchester, and Mattapan. New neighborhoods have developed in Jamaica Plain, Hyde Park, Roslindale, and the Allston section of Brighton. Currently, Boston's African American population numbers approximately 120,000.

NOTES

1. Robert C. Hayden's book, *African-Americans in Boston: More Than 350 Years* (Boston: Boston Public Library, 1991), proved an indispensable resource in the development of the above text. Gallery assistants Reyahn King and Kate Mateson provided research assistance.

2. Evidence suggests that black Africans may have lived in the Boston area even earlier. See Lorenzo J. Greene, *The Negro in Colonial New England* (New York: Athenaeum, 1991).

3. Robert C. Hayden, *African-Americans in Boston*, p. 22.

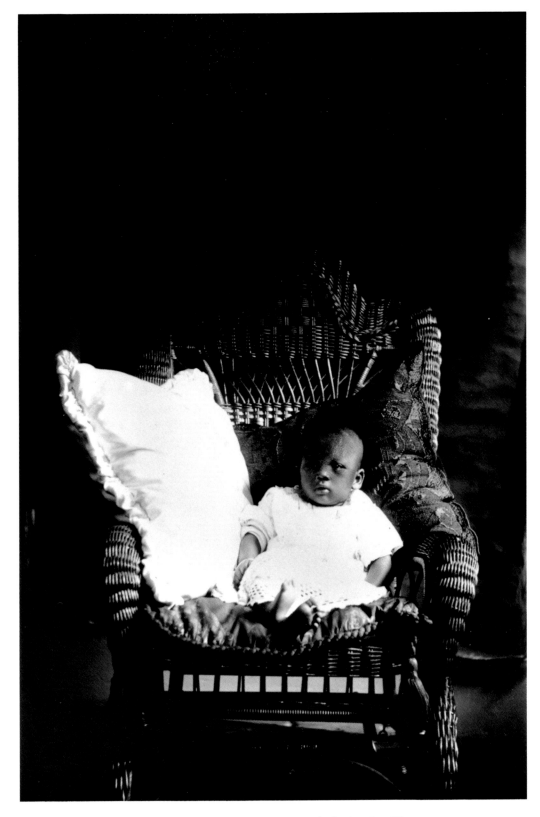

FIG. 10. Herbert Collins, *Mrs. Both's Baby*, c. 1910-1916, Museum of Afro-American History

HERBERT COLLINS

Herbert Collins's work has been recognized as among the important early photographs of Boston. Little is known of the photographer's life, except that he lived at 18 Northampton Street in Lower Roxbury from 1910 to 1916. He operated a photography business in the South End, and may have been employed by real estate developers to photograph new construction, not yet landscaped, in Allston, Brighton, and Cambridge. Although he is listed as a janitor in the directories, he later worked for Montgomery Frost, a lens company, as an eyeglass grinder. Collins later lived on Shawmut Avenue until the 1960s, and he died in 1966.

During his photographic career, which probably ranged from about 1890 to around 1920, Collins photographed middle-class African American families and acquaintances as well as the new houses mentioned above. One hundred and three negatives were found in his basement, including forty-five with their sitters identified, and they now form part of the collections of the Museum of Afro-American History.

—Kim Sichel

1882	Born in Boston, Massachusetts.
1910–16	Lived in Lower Roxbury and operated a photography business from his home.
1940–42	Discontinued photography business and began working for Montgomery Frost as a lens grinder.
1966	Died in Rhode Island.
1976	Glass plates belonging to Collins are discovered in an old brownstone. Some of his work is subsequently reproduced in *Black Bostonia,* a book in the Neighborhood History Series produced by the Boston 200 Corporation.
1983	"A Century of Black Photographers: 1840–1960," Museum of Art, Rhode Island School of Design, Providence, Rhode Island.
1984	"A Century of Black Photographers: 1840–1960," Newark Museum of Art, Newark, New Jersey.
1985	"The Black Photographer: An American View," the Chicago Public Library Cultural Center, Chicago, Illinois. His work is seen in Deborah Willis-Thomas's publication, *Black Photographers, 1840–1940: An Illustrated Bio-Bibliography,* published by Garland.

Selected Public Collections

Museum of Afro-American History, Boston, Masschusetts.

FIG. 11. Paul Rowell, Boston Elevated Railway Company, *View of Lindall Place from West Cedar Street, Boston*, July 24, 1911, Society for the Preservation of New England Antiquities

PAUL ROWELL

Paul Rowell was employed by the Boston Elevated Railway Company (BERY) between 1898 and 1935. His first assignment entailed photographing all the buildings along the projected route of the new elevated railway before construction started. His extensive recording chronicles the technical and engineering progress of the company. Further, these photographs document the neighborhoods before the building of the elevated railway, and were used as records to protect the BERY from damage claims.

In 1897 BERY incorporated the West End Railway Company, an organization that had already used photographic documentation of their projects. The West End Railway Company hired a full-time photographer, Rudolph E. Maier, in 1895 to head their new Transit Systems Photographic Department. By 1903 Paul Rowell had taken over all of Maier's work, except that of the Claims Department. Rowell devised his own system of marking his negatives. He would etch a number into the glass negative plates' lower right corner, then add the date of exposure and a title referring to the location.

Rowell's series of photographs taken around Lindall Place in 1911 were intended to document the construction of a part of an elevated connection built by the BERY between Longfellow Bridge (former Cambridge Bridge) and Grove Street.

—Andrea Lange

1898	Hired as a professional photographer by the Boston Elevated Railway Company to document all stages of their new construction project.
1903	By this date, Rowell was responsible for all photographic work done for the Boston Elevated Railway Company, except work for the Claims Department.
1931	Ray Ammidown became Rowell's assistant. Ammidown had begun work in the Track Department of the Boston Elevated Railway Company in 1918, and was subsequently trained in photography by Rowell.
1935	Retired from the company. Ammidown continued to document the company's engineering projects.

Selected Public Collections

Society for the Preservation of New England Antiquities, Boston, Massachusetts.

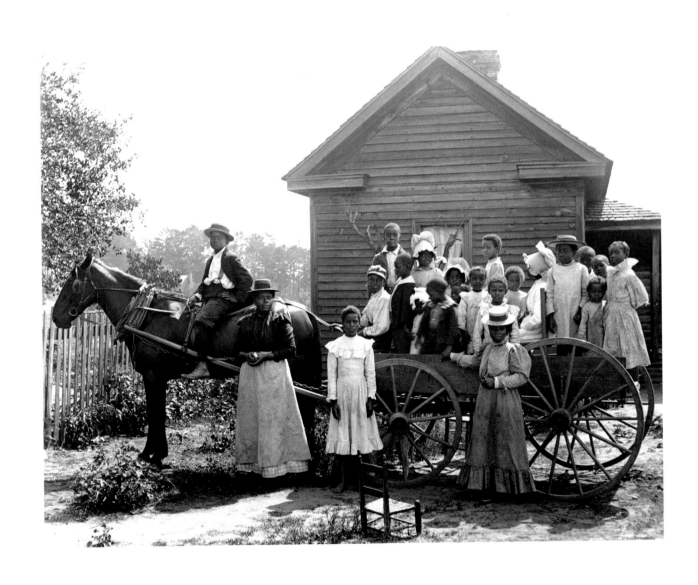

FIG. 12. Margaret Sutermeister, *School Wagon*, c. 1900, Milton Historical Society

By the age of eighteen, Margaret Sutermeister was interested in collecting photographs, and that interest quickly expanded into creating them as well. Within the firmly defined world of late-Victorian middle-class society, Sutermeister functioned as a recorder of the emblems of Victorian values: the home and family. However, there is another body of work that does not fit into this formula. These photographs capture the images of those who played unrecognized roles in late-nineteenth-century middle-class society. And yet Sutermeister sought them out—laborers and laundrymen, maids and peddlers, African American farmers and Native American basket weavers. Sutermeister's photographs also capture images of poor and middle-class African Americans whose lives and social roles were largely unrecognized in their own time.

Sutermeister moved comfortably between the different worlds in which she played the part of chronicler. Yet in its multi-faceted focus, her work also documents the complexity of turn-of-the-century society. The differences in the self-images of whites, Asians, Gypsies, African Americans, and Native Americans, all of whom pass before Sutermeister's lens, may be due in part to ethnic factors, but seem more strongly affected by issues of economic and social status.

—Judith Bookbinder

1875	Born in Milton, Massachusetts.
1894	Approximate date when Sutermeister began photographing in Milton and in neighboring towns. Photographic evidence suggests that she traveled to Canada and possibly visited the southern United States.
1900	Approximate date when Sutermeister stopped photography.
1904	James Munson Barnard donated one hundred "Views of Milton" by Sutermeister to the Milton Historical Society.
1909	Following her father's death, she took control of the family's floral nursery in Milton.
1950	Died, Milton, Massachusetts.
1951	After her Milton residence is sold, eighteen hundred of Sutermeister's glass negatives are found. Among this collection are negatives from her "Views of Milton."
1993	"Margaret Sutermeister, Chronicling Seen and Unseen Worlds, 1894–1909," Milton Art Gallery, Milton, Massachusetts.

Selected Public Collections

Milton Historical Society, Milton, Massachusetts.

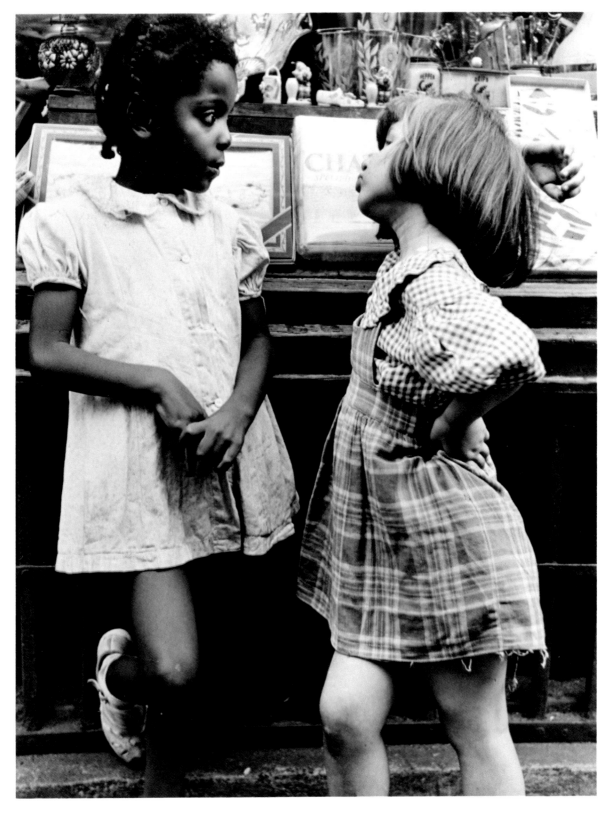

FIG. 13. Jules Aarons, *Conversation Piece II*, c. 1948-1951, Collection of the artist

The West End of Boston had a history of welcoming waves of immigrant groups into its relatively small confines. The West End is the area now occupied by Charles River Park ("If You Lived Here You'd Be Home Now") and other new buildings. But between 1948 and 1953, when I wandered its streets, it was an integrated area.

My interest was in photographing people as they carried on their lives in the streets. Frankly, I was following the work started in New York by Helen Levitt, Aaron Siskind, Sid Grossman, and others. The West End was populated by working-class people, and they used the streets where they lived for shopping, for school, for playing, and for social mixing. It was an exciting place to photograph.

The camera I used was a Rolleiflex Twin Lens Reflex. Having a waist-level camera made it easy to photograph without being too obvious. In many cases it was possible to mingle with the group involved, children and adults, and take photographs without their knowledge. The children in these photographs would not be aware of the photographer and frankly, at this time, the photographer was not really welcome in areas such as this.

In 1957 and 1958, the Boston Redevelopment Authority "renewed" the area by bulldozing the West End and building a middle-class apartment complex. Recently, an exhibition showing the history of the West End was developed by the Bostonian Society and is presently housed in the Old State House.

—Jules Aarons

1921	Born in New York, New York.
1948	Began six-year photographic documentation of the West End in Boston.
1949	Solo exhibition, Massachusetts Institute of Technology, Cambridge, Massachusetts.
1951	"The Photographs of Jules Aarons," De Cordova Museum and Sculpture Park, Lincoln, Massachusetts.
1951	Solo exhibition, "Life in Boston," Institute of Contemporary Art, Boston, Massachusetts.
1958	Solo exhibition, "The Onlookers," George Eastman House, Rochester, New York.
1962	Curator, "Photography USA," De Cordova Museum and Sculpture Park, Lincoln, Massachusetts.
1972	Curator, "The New England Experience," De Cordova Museum and Sculpture Park, Lincoln, Massachusetts. Solo exhibition at the Carl Siembab Gallery, Boston, Massachusetts.
1978	"Boston's West End," Carl Siembab Gallery, Boston, Massachusetts.
1980	Photography reproduced in Jane Holtz Kay's *Lost Boston* and *Lost New England*.
1992	"The Last Tenement," The Old State House, Boston, Massachusetts.

Selected Public Collections

The Museum of Modern Art, New York; Bibliothèque Nationale, Paris.

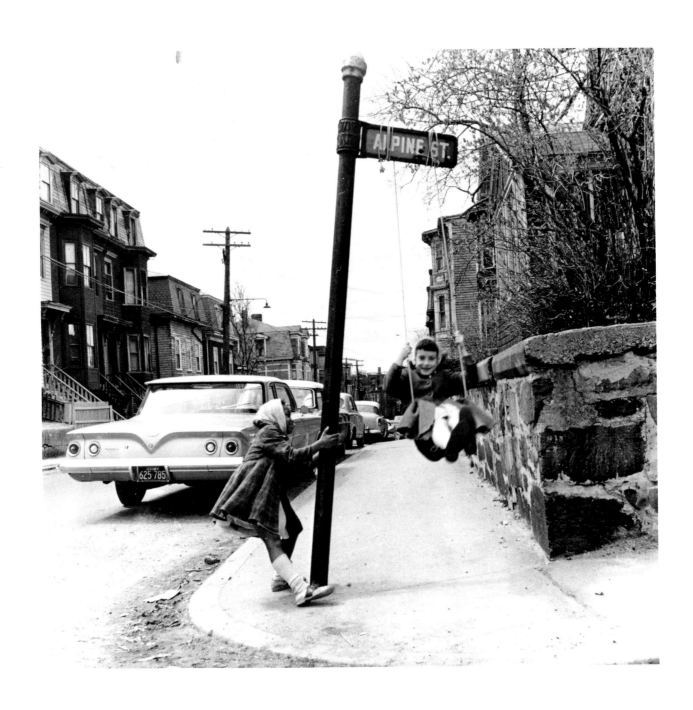

FIG. 14. Irene Shwachman, *Palm Sunday*, 1962, Freedom House Collection, Archives and Special Collections Department, Northeastern University Libraries

IRENE SHWACHMAN

In 1959, Irene Shwachman began photographing the streets, buildings, and inhabitants of Boston for a photographic series that would later be titled "The Boston Document." Comprising images from Cambridge to Roxbury, this project occupied Shwachman for nearly a decade. Though she had taken her own "amateur" photographs since the age of twelve, this work represented her first sustained documentary project. A meeting with photographer Berenice Abbott in 1959 seems to have been pivotal for Shwachman. Her "Boston Document" and Abbott's exploration of New York in the 1930s, "Changing New York," share similar concerns. Both utilize a direct "documentary style" and seem paradoxically attracted to and repelled by urban renewal. In her unpublished statement for the "Boston Document" project, Shwachman describes her own motivations:

> The event that set this in motion was the destruction of the West End. My husband had grown up there, and hated to see it go. . . . Well aware of the work of Eugène Atget in Paris and Berenice Abbott in New York, I wanted to show the upheaval caused by urban renewal, and the special quality of Boston, a city that was new to me, a confirmed New Yorker.

By the end of the "Boston Document" in 1968, Shwachman had taken at least two thousand photographs of Boston.

—Christine Hult

1915	Born Irene Shirley Quinto in New York, New York.
1932–35	Attended Columbia University in New York, where she majored in theatrical production and education.
1946	Settled in Boston, Massachusetts, and joined the Boston Camera Club.
1951–68	Worked as a free-lance photographer in Boston.
1959	Began an independent project entitled "The Boston Document," in response to the destruction of the West End.
1962–63	Photographer for the Boston Redevelopment Authority. Her primary work was documenting the Washington Park area of Roxbury.
1962	Solo exhibition, "Boston Today: The Changing Face of the City, 1959–1961," Boston Athenaeum, Boston, Massachusetts.
1971	Solo exhibition, Carl Siembab Gallery, Boston, Massachusetts.
1973	Solo exhibition, Imageworks, Cambridge, Massachusetts. Member of the advisory panel on the visual arts, Massachusetts Council of the Arts.
1981	Solo exhibition, Carl Siembab Gallery, Boston, Massachusetts.
1988	Died in August.
1989	Retrospective exhibition, Photographic Resource Center, Boston, Massachusetts.

Selected Public Collections

Northeastern University, Boston, Massachusetts; Center for Creative Photography, University of Arizona, Tucson, Arizona.

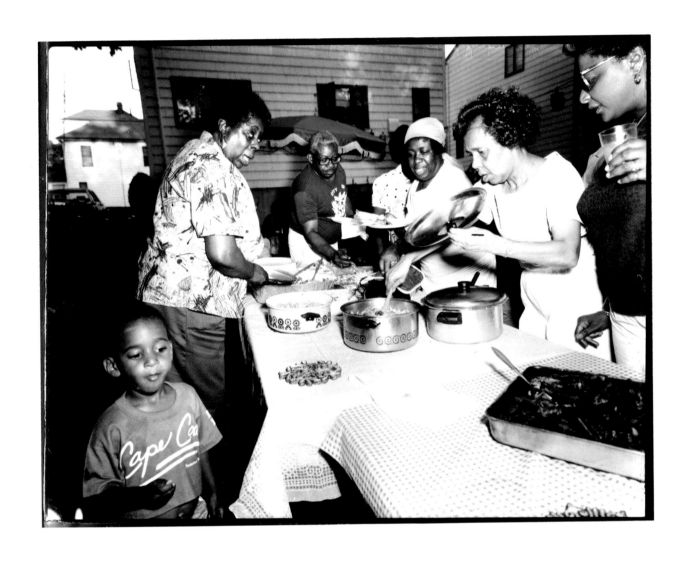

FIG. 15. Polly Brown, *Fourth of July, Mattapan*, 1985, Collection of the artist

POLLY BROWN

In 1985 I began a book project with three other photographers documenting the evolving neighborhoods of Boston. I was responsible for photos of the neighborhoods of Roxbury, Mattapan, and the South End. For me, this project was immensely rewarding—both personally and photographically.

A neighborhood is a social and moral concept. It is a cohesive community within the larger unit of a city, with some common identifying features such as economic conditions, ethnic background, or religion. These distinctive features are defined by the local schools, churches, business establishments, and recreational facilities.

Documentary photography is a way of learning about the world by photographing it. A simple concept maybe, but we human beings tend to be a provincial lot, defining ourselves within the parameters of our friends and rituals that orient us in our own existence. The Boston neighborhood project enabled me to leave those confines, and, by doing so, I learned about this city and its people. I developed a persistent curiosity to know the real nature of Boston. I could leave Huntington Avenue and turn onto Tremont Street in Mission Hill and be in a different world, much of it defined by the spirituality of the Mission Church. The Talk of the Town barber shop on Seaver Street in Roxbury would become a crowded social center every Saturday morning. Most rewarding was being invited into the homes of the area's generous people while they were celebrating Christmas with their families or barbecuing in their back yards over the Fourth of July.

Boston has many complex problems: my intention is not to ignore or belittle them, but to tell about my own experience, which has been affirming and hopeful. I have been fortunate to be photographing in these areas before they became the neighborhoods of the past.

—Polly Brown

1941	Born in New York, New York.
1982	Began her book, *Children with Children,* which documents teenage mothers.
1984	Massachusetts Artist's Fellow in Photography.
1985	Associate professor of documentary photography at the Art Institute of Boston, a position she holds to the present.
1986	Participated in *City Limits,* a book on Boston's neighborhoods, published by Northeastern University Press.
1988	Awarded a National Endowment for the Arts fellowship. "Generations," Smithsonian Institution, Washington, D.C. "Crosscurrents," Photographic Resource Center, Boston, Massachusetts. Exhibited work at the "Photokina '88," Polaroid Gallery, Cologne, West Germany.
1989–90	Instructor of documentary photography, the International Center of Photography, New York, New York.
1990	Solo exhibition "The Rites of Man," Howard Yezerski Gallery, Boston, Massachusetts. "Body Language! The Figure in the Art of Our Time," Rose Art Museum, Brandeis University, Waltham, Massachusetts.
1993	Awarded a Ruttenberg Foundation grant by the Friends of Photography.

Selected Public Collections

Rose Art Museum, Brandeis University, Waltham, Massachusetts; Carpenter Center for Visual Arts, Harvard University, Cambridge, Massachusetts; The Addison Gallery of American Art, Phillips Academy, Andover, Massachusetts.

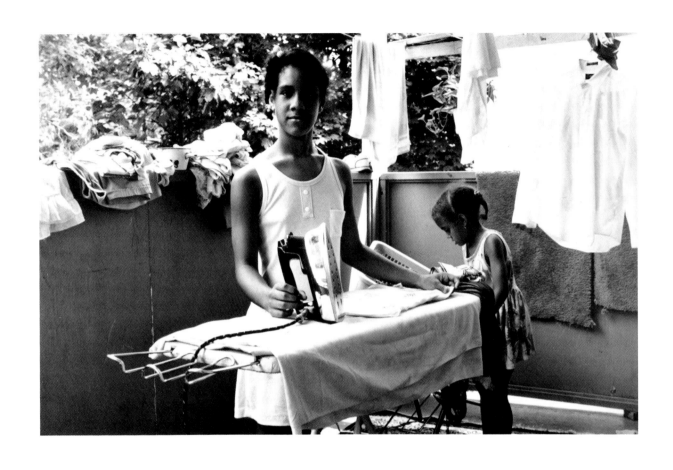

FIG. 16. Beverly Conley, *Bernadette and Benvinda Teixeira Helping with the Laundry*, 1988, Boston Public Library, Print Department

A majority of my documentary projects are self-motivated and focus on a cultural group and its environment. Most important, these projects involve something I feel passionately about.

While living in Dorchester, I became acquainted with the Cape Verdean community. From the beginning, these people fascinated me with their ability to maintain strong family and religious ties despite the adversity of their surroundings. In my photographs, I sought to capture the dignity and strength of the Cape Verdeans while documenting certain aspects of their lives.

My project began in 1987 with the encouragement and assistance of Father Pio, a Capuchin priest at St. Patrick's church in Roxbury. The church is a focal point for many of the thousands of Cape Verdeans residing in Dorchester and Roxbury.

Although I did not speak Crioulo, I discovered that by giving pictures away I was able to show what I was doing and also that I was photographing honestly and with respect for their lives. Gradually, it was possible to gain the trust that is so vital to the way I work.

—Beverly Conley

1944	Born in Willits, California.
1978	Received an Associate of Arts in Photography degree, San Francisco City College, San Francisco, California.
1984	Began her work as a freelance photographer in Boston, Massachusetts. From 1990 to the present, she has worked primarily in New York City and London.
1986	Participated in an architectural survey of Boston, sponsored by Greater Boston Community Development.
1987	Photodocumentary on the Kit Clark Senior House, in the Dorchester section of Boston, Massachusetts.
1988	Solo exhibition, Light Source Gallery, Boston, Massachusetts.
1989	Solo exhibition, Fogg Museum of Art, Harvard University, Cambridge, Massachusetts. Her photographs are reproduced in *East Cambridge,* a book sponsored by the Cambridge Historical Commission, Cambridge, Massachusetts. "Cultural Reactions," Harriet Tubman Gallery, Boston, Massachusetts.
1990	Participated in the book, *Cranberry Harvest,* produced by Spinner Publications. Traveled to Cape Verde. Group exhibition, South Bank Photo Show, London, England.
1993	Solo exhibition, "A Salute to the Cape Verdean Community in Boston," Boston Public Library, Boston, Massachusetts.

Selected Public Collections

Boston Public Library, Boston, Massachusetts; New York Public Library, New York; Museum of London, England; Cambridge Historical Commission, Cambridge, Massachusetts.

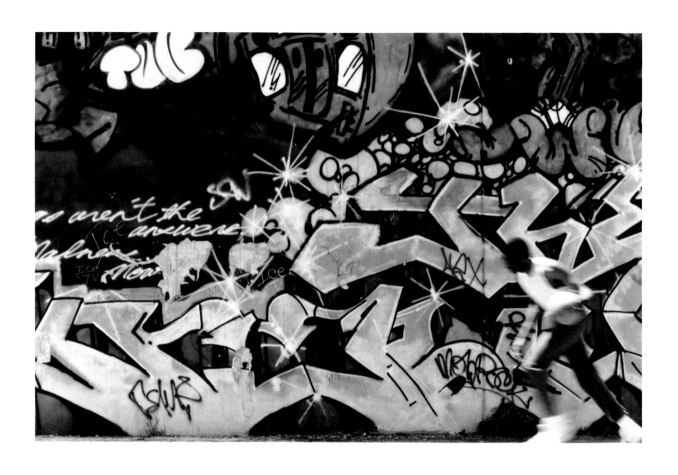

FIG. 17. Lou Jones, *Graffiti Basketball*, 1984, Collection of the artist

It seems to me that photography can take you great distances—internally and externally. I have been fortunate enough to take pictures on four continents, but still find inspiration around my neighborhood. The photographs in this exhibition were all taken within walking distance of my studio. All but one were dramatic moments, on assignment for the MBTA, City Hall, and Boston Magazine. *They became the poetry that accompanied a client's prose.*

The assignments were fraught with political undertones. The people portrayed are from environments in flux and have little to say about their new directions. These politics are complex. They involve people's lives. Art simplifies: it is never exactly equal to life but it may illuminate.

The pictures are urban, that is, of the city. They are sudden. Many of them are transient. The structures have been razed, the graffiti have been painted over. But art is less capricious than reality. The function of photography is not to make us see accurately but to see better.

We must bear witness while it's there, because then it is history.

—Lou Jones

1945	Born in Washington, D.C.
1967	Received a Bachelor of Science from Rensselaer Polytechnic Institute, Troy, New York.
1971	Began working as a free-lance photographer, an occupation he continues to the present.
1978	"Black Photographer's Annual," Corcoran Gallery of Art, Washington, D.C.
1978	Solo exhibition, "Four Corners/Four Continents," Boston City Hall, Boston, Massachusetts.
1979	Solo exhibition at the Polaroid Gallery, Cambridge, Massachusetts. "Black Photographer's Annual," San Francisco Museum of Modern Art, San Francisco, California.
1981	Taught a seminar at the New England School of Photography, Boston, Massachusetts.
1982–86	President of the New England Chapter of American Society of Magazine Photographers.
1984	Taught seminar at the College of Communication, Boston University.
1991	Solo exhibition, "Sojourner's Daughters," Museum of Afro-American History, Boston, Massachusetts.
1992	Visiting lecturer at Massachusetts College of Art in Boston, a position he holds to the present. Solo exhibition, "On Assignment," New England School of Art and Design, Boston, Massachusetts. "20th Anniversary of Black Photographer's Annual," The Crawford Sloan Gallery, New York.
1993	Solo exhibition, "Every Color Has a Different Song," Feuerwehr Wagner, Vienna, Austria.

Selected Public Collections

Museum of Afro-American History, Boston, Massachusetts.

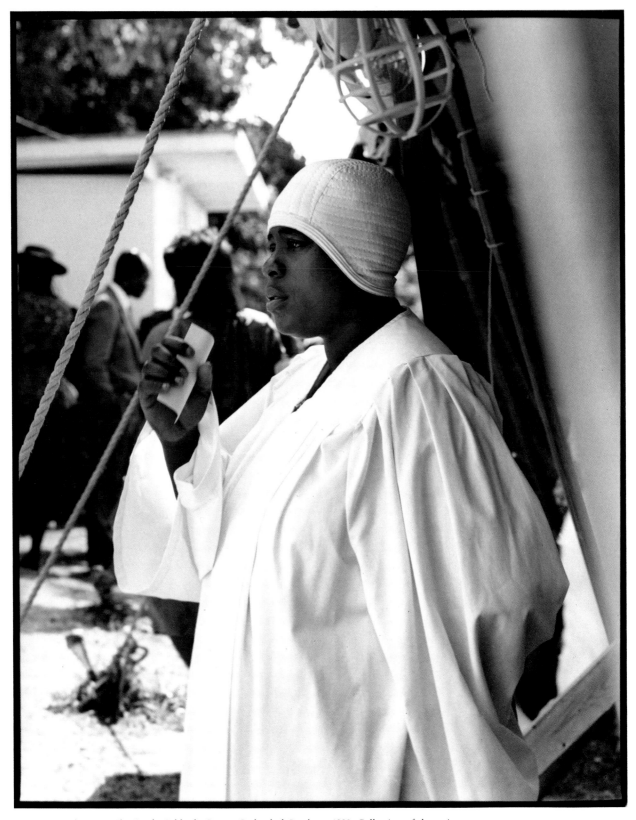

FIG. 18. Hakim Raquib, *On the Sabbath: Canvas Catherdral, Roxbury*, 1992, Collection of the artist

For the past twenty years I have worked as a professional photographer in both the private and public sectors. As a free-lance photographer, I developed several styles and techniques to accommodate the variety of assignments I received. Operating a studio in Boston and New York has enhanced my knowledge and understanding of the commercial world. This background set the stage for where I am today.

Since 1987, I have been exhibiting and teaching as a photographic artist. After several years of commercial work, I realized my purpose: to utilize photography as an artistic and aesthetic means of expression that reflects the spirit of our times, and to provide diverse viewpoints that draw from and bridge a broad range of cultural traditions.

The new infusion of Asian, Caribbean, and Hispanic cultures in North America creates both a need and a foundation for cross-fertilization in the visual arts. A realization of history provides a reference—a source of information and understanding—for emerging artists. For artists of color, this perspective has historically either been missing, misrepresented, negated, or isolated. For the general population, the inclusion of diverse perspectives broadens the creative possibilities in developing solutions toward cultural pluralism.

—Hakim Raquib

1946	Born in Panama.
1969–70	Attended Photography and Creative Application program at Massachusetts Institute of Technology, Cambridge, Massachusetts.
1970	Awarded a Mellon Foundation grant and began two-year coursework in the Roxbury Photographers Training Program, Massachusetts Institute of Technology, Cambridge, Massachusetts.
1989	Began work as Staff Archival Photographer for the Museum of the National Center of Afro-American Artists, Boston, Massachusetts. Artist-in-Residence, the African-American Master Artist-in-Residence Program, Northeastern University, a position Raquib holds to the present. Solo exhibition, "Neighborhoods Talk," Boston Public Library, Boston, Massachusetts.
1990	Received a Polaroid Foundation film grant. Solo exhibition, "Majestic Ruins: Great Zimbabwe," Museum of the National Center of Afro-American Artists, Boston, Massachusetts.
1992	"Ways to See," Institute of Contemporary Art, Boston, Massachusetts. "Revisions/Assemblage," Polaroid Gallery, Cambridge, Massachusetts.
1993	"Tribute to Black History," Copley Society Gallery, Boston, Massachusetts.

Selected Public Collections

Massachusetts Institute of Technology, Cambridge, Massachusetts; Museum of the National Center of Afro-American Artists, Boston, Massachusetts.

1. Herbert Collins
Derbied Man in Front of Brick Residence, c. 1910–1916
6 1/4 x 4 1/2 in.
Museum of Afro-American History

2. Herbert Collins
Hubert C. Collins (?), c. 1910–1916
6 1/2 x 4 3/4 in.
Museum of Afro-American History

3. Herbert Collins
Mrs. Tell's Children, c. 1910–1916
6 3/8 x 4 3/4 in.
Museum of Afro-American History

4. Herbert Collins
Three Top-hatted Gentlemen, c. 1910–1916
6 1/2 x 4 3/4 in.
Museum of Afro-American History

5. Herbert Collins
Mrs. Both's Baby, c. 1910–1916
6 5/8 x 4 1/2 in.
Museum of Afro-American History

6. Herbert Collins
Knights of Pythias, c. 1910–1916
8 x 10 in.
Museum of Afro-American History

7. Paul Rowell, Boston Elevated Railway Company
West Side of Lindall Place, Boston, June 3, 1911
8 x 10 in.
Society for the Preservation of New England Antiquities

8. Paul Rowell, Boston Elevated Railway Company
View of Lindall Place from West Cedar Street, Boston,
July 24, 1911
8 x 10 in.
Society for the Preservation of New England Antiquities

9. Paul Rowell, Boston Elevated Railway Company
8 Lindall Place, Boston, November 11, 1911
8 x 10 in.
Society for the Preservation of New England Antiquities

10. Paul Rowell, Boston Elevated Railway Company
3 Lindall Place, Boston, November 11, 1911
8 x 10 in.
Society for the Preservation of New England Antiquities

11. Paul Rowell, Boston Elevated Railway Company
Lindall Place, Boston, December 1, 1911
8 x 10 in.
Society for the Preservation of New England Antiquities

12. Paul Rowell, Boston Elevated Railway Company
3 Lindall Place, Boston, December 1911
8 x 10 in.
Society for the Preservation of New England Antiquities

13. Margaret Sutermeister
Family Group in Front of Home, c. 1900
11 x 14 in.
Milton Historical Society

14. Margaret Sutermeister
Women and Children in Back Yard, c. 1900
14 x 11 in.
Milton Historical Society

15. Margaret Sutermeister
Family Group Portrait, c. 1900
11 x 14 in.
Milton Historical Society

16. Margaret Sutermeister
Woman in White Dress with Dog, c. 1900
11 x 14 in.
Milton Historical Society

17. Margaret Sutermeister
*Postmortem Photograph of an Infant Held by Two Women
and a Girl*, c. 1900
14 x 11 in.
Milton Historical Society

18. Margaret Sutermeister
School Wagon, c. 1900
11 x 14 in.
Milton Historical Society

19. Jules Aarons
Long Shadows, c. 1948–1951
14 x 11 in.
Collection of the artist

20. Jules Aarons
Conversation Piece I, c. 1948–1951
14 x 11 in.
Collection of the artist

21. Jules Aarons
Conversation Piece II, c. 1948–1951
14 x 11 in.
Collection of the artist

22. Jules Aarons
Conversation Piece III, c. 1948–1951
10 x 8 in.
Collection of the artist

23. Jules Aarons
Two Girls, c. 1948–1951
10 x 8 in.
Collection of the artist

24. Irene Shwachman
Freedom House Coffee Hour, 1960
8 x 10 in.
Freedom House Collection, Archives and Special Collections
Department, Northeastern University Libraries

25. Irene Shwachman
Garden Project (Five Women), 1960
8 x 10 in.
Freedom House Collection, Archives and Special Collections
Department, Northeastern University Libraries

26. Irene Shwachman
Garden Project (Three Women), 1960
8 x 10 in.
Freedom House Collection, Archives and Special Collections
Department, Northeastern University Libraries

27. Irene Shwachman
Grosvenor Place, Washington Street, 1962
8 x 10 in.
Freedom House Collection, Archives and Special Collections
Department, Northeastern University Libraries

28. Irene Shwachman
Bower Street, 1960
8 x 10 in.
Freedom House Collection, Archives and Special Collections
Department, Northeastern University Libraries